TCHEREVKOFF
THE IMAGE MAKER

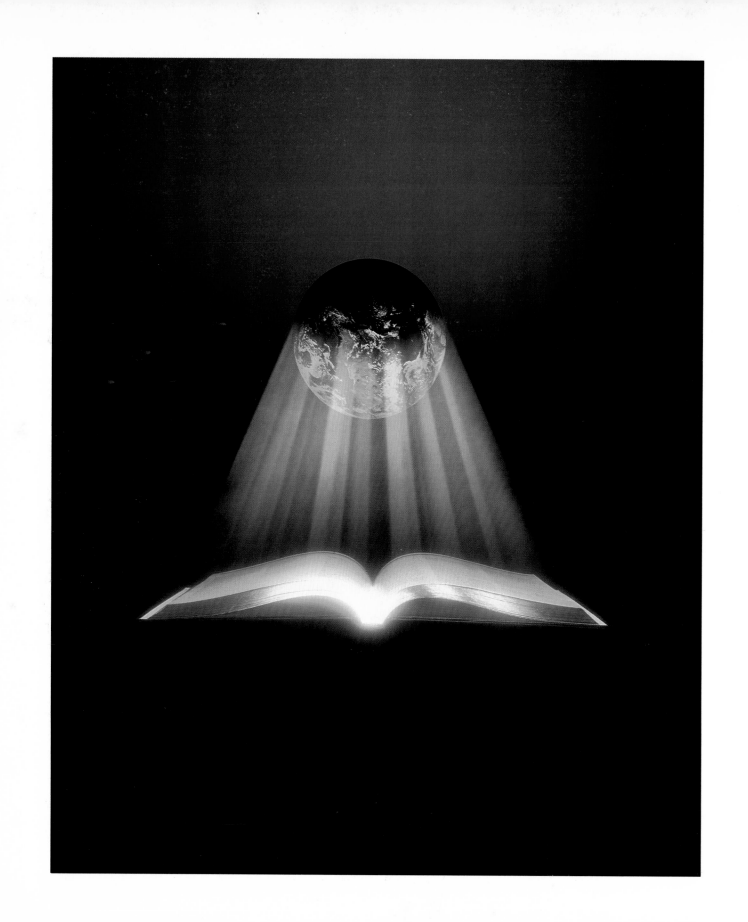

TCHEREVKOFF
THE IMAGE MAKER

MICHEL TCHEREVKOFF

A BALDEV DUGGAL BOOK

AMPHOTO
An imprint of Watson-Guptill Publications
New York

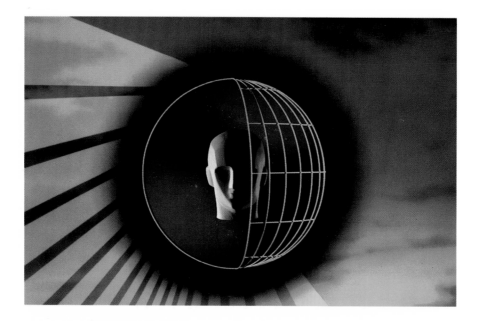

Production by Ellen Greene
Design by Bob Fillie

Copyright © 1988 by Michel Tcherevkoff

First published 1988 in New York by AMPHOTO,
an imprint of Watson-Guptill Publications,
a division of Billboard Publications, Inc.,
1515 Broadway, New York, NY 10036

Library of Congress Cataloging-in-Publication Data

Tcherevkoff, Michel.
The image maker.
Includes index.
1. Photography—Special effects. 2. Tcherevkoff,
Michel. I. Title.
TR148.T44 1988 778.8'092'4 88-16716
ISBN 0-8174-4014-3
ISBN 0-8174-4015-1 (pbk.)

Manufactured in the United States of America

1 2 3 4 5 6 7 8 9 / 96 95 94 93 92 91 90 89 88

TO: Veronica, Sasha, Sonya, Helene, Moura, and Alec

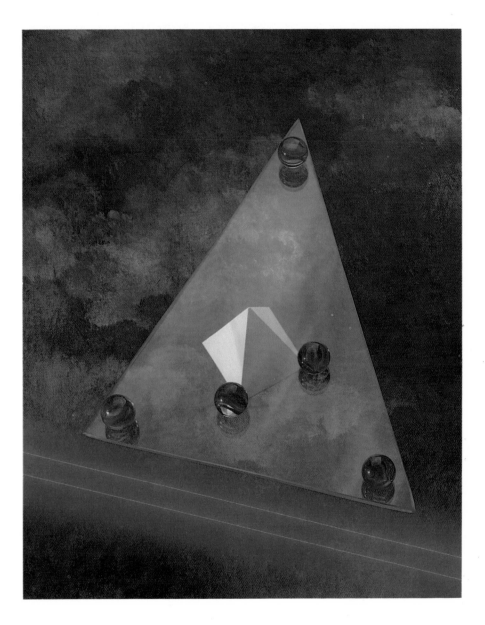

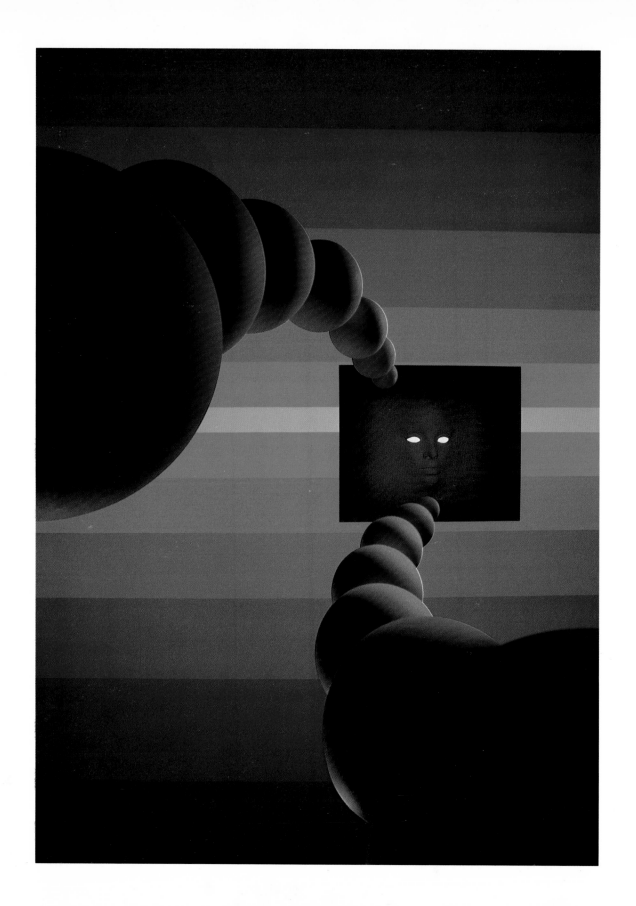

ACKNOWLEDGMENTS ❑ Before this book had form, it was an idea. I would like to thank Baldev Duggal for making that idea a reality, Ray De Moulin for his enthusiastic support, and my editor, Susan Hall, whose patience and humor guided me throughout.

Before this book was an idea, there were clients, friends, and associates who trusted and supported me over the years. Thank you: Jim McGuirk, Douglas Rosenman, Hans Van Der Bovenkamp, Susan Orsini, Serge Popper, Pete Turner, Eric Meola, Dinah Davidson, Jim Gager, Charles Barral, The Image Bank, Nob Hovde, Roger Blatz, Ellen Greene, Dawn Smith, Elizabeth and Michael Simpson, Elizabeth Hathon, Frank Marchese, Ric Cohn, Leland Tannen, Marisa Bulzone, George Sell, Orit, Sara Oliphant, Sandro LaFerla, Jacques Paucker, John Craven, Joni Tuke, Debra Wolfe, Sally Sargeant, Bill Dunn, Douglas and Jane Warwick, William Hufstader, Koos Van der Akker, Rita Walsh, and all those I haven't forgotten but have failed to mention.

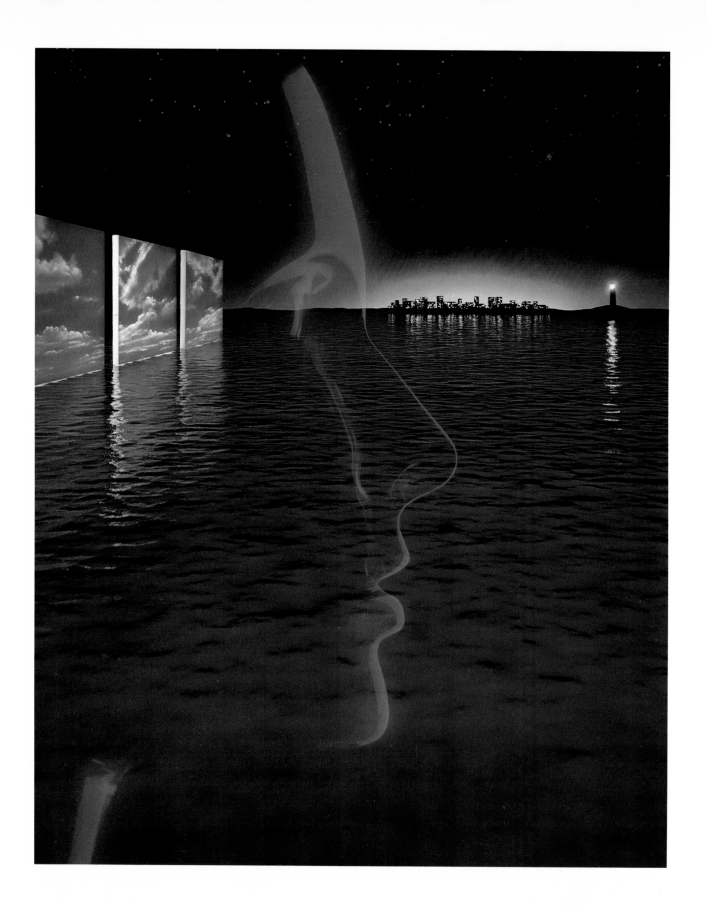

INTRODUCTION

I never planned to be a photographer.

As a child growing up in France I was a passable student with a vivid imagination and tremendous energy. I was far more comfortable with imagery than with verbal processes. I like to think that if I had gone to art school I would have been a painter or an illustrator, but I knew I wasn't good enough. My parents agreed. At eighteen I was in law school and miserable.

It was a series of serendipitous circumstances that led me to photography. I came to America to visit my sister who was modelling in New York at the time. Discovering that in this country all things are possible if you have imagination and the will to make your dreams a reality, I stayed.

I had never held a camera, my experience was nonexistent, and my English was lousy, but through my sister's connections I took a job as a photographer's assistant with the first person who offered me a position: Pete Turner always does the unexpected.

Pete didn't pay his assistants very much, but he gave us far more than wages, he gave us possibilities. I worked in his studio for a year and a half, and I learned how to visually interpret a thought. First get the concept, then create the technique to implement it.

Although "taking" a picture never particularly interested me, creating one was endlessly fascinating. Maybe I was uncomfortable with the concept of recording what already existed because it seemed like subtly plagerizing reality. But shaping something of my own from the countless mental images that I had framed and filed in my mind since I was a boy involved the same creative process as painting or sculpture. I was hooked immediately.

I had discovered the basics of composition and design studying art in museums, but photography involved a new tool, the camera. I didn't want to spend time laboring over equipment. I wanted to concentrate on the concept and production of the image, but first I had to learn the techniques.

The beginning was difficult. I worked days assisting and spent what was left of the night playing with lights, shapes, surfaces, and all the photographic paraphernalia I could get my hands on in an-

ticipation of the time when I would be on my own. After I understood the technique, I realized that it wasn't as important as the thinking behind it, and that part of successful design is understanding the relationship of space and form and how to make that relationship harmonious.

Maybe it was my heritage that made me feel comfortable traveling unmarked roads, maybe it was the hubris of being young, but when I began working in the studio, I started with 35mm cameras, which was an oddity for a table-top photographer. Instinct dictated that my light be simple and stark, one light on the background and one on the foreground. My colors were intense and saturated. My approach was radical. I startled art directors into noticing me.

I may have been noticed for being avant garde, but my early assignments were very much in the mainstream. With each layout I pushed myself to find a new angle, a different way to solve a problem, always looking to simplify the process while enhancing the result. I wanted to make every image something new, something a little different and unexpected. That's probably why I began creating those visual illusions known as special effects. I never used them as an end in themselves, but rather as a means to visually bend reality into a novel form.

Creatively and technically I was growing. Thirty-five millimeter had become too confining, and I started to work in larger format, primarily 4×5, which gave me the latitude and flexibility I needed for the new techniques I was seeking. By trying everything from spit and glue to lasers and electronic pixelizations, I often got my most unexpected and effective results. I learned that nothing is too advanced or too primitive to convey the demanded concept.

Eighteen years later, using the camera as a brush, technique as paint on a pallette, and film as a canvas, I find myself painting in my own way, unconsciously interpreting everything I touch, hear, and see, into a visual design.

I've always felt I was on the outside looking in. Photography not only gives me permission to be on the outside, but rewards me for being there. The camera is always between me and the image, distancing me yet encouraging me to look rather than speak and, ultimately, giving my work the celebrity while I remain comfortably anonymous.

If I am successful, it's because I love what I do—making images that seamlessly blend illusion into reality. The magic of my work is making the seams invisible. The joy of my work is making the magic. ❑

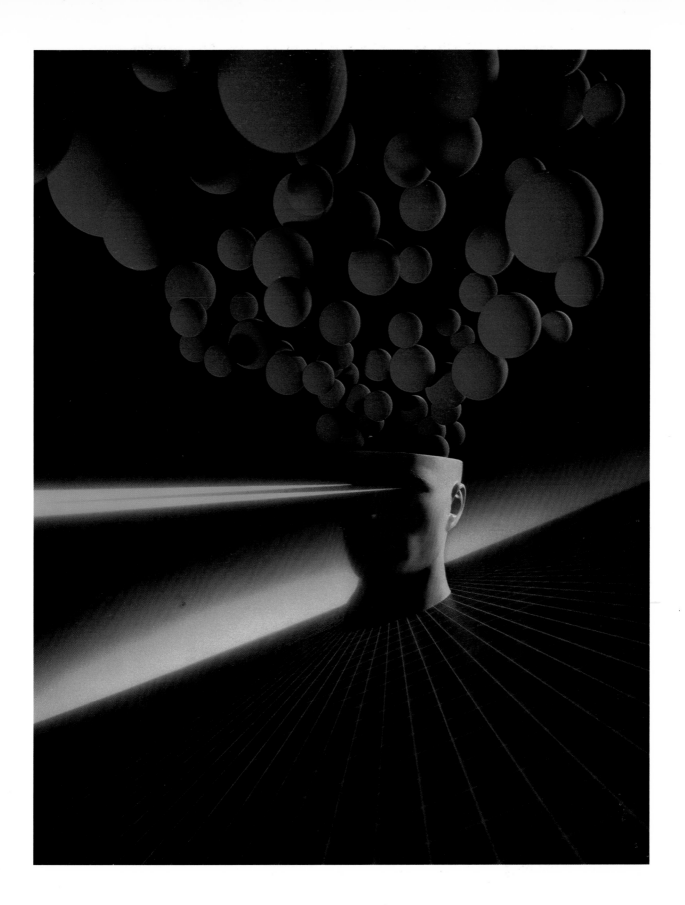

General Motors conceived a sophisticated advertising campaign for their Research Laboratories Division that would run as a three-page supplement in national magazines. I love to create concepts for my clients, but when the layout is perfect, why change it?

My challenge in the four images that follow was to make the execution as compelling as the original ideas.

THE NATURALIZATION PAIRING ❏ This illustration for the cover of the supplement was to be the distillation of a rather complex theory about the optimal use of statistics from GM's research laboratories. The theory is that the accurate pairing of statistics is essential to assessing data, in this case fatalities of drivers and of passengers in automobile accidents.

For the cubes, I used the same colors that were chosen by the GM scientists for use inside the supplement. The dramatic design hooks the consumer to read: "GM's new method in accurately determining the effectiveness of safety belts in preventing traffic fatalities."

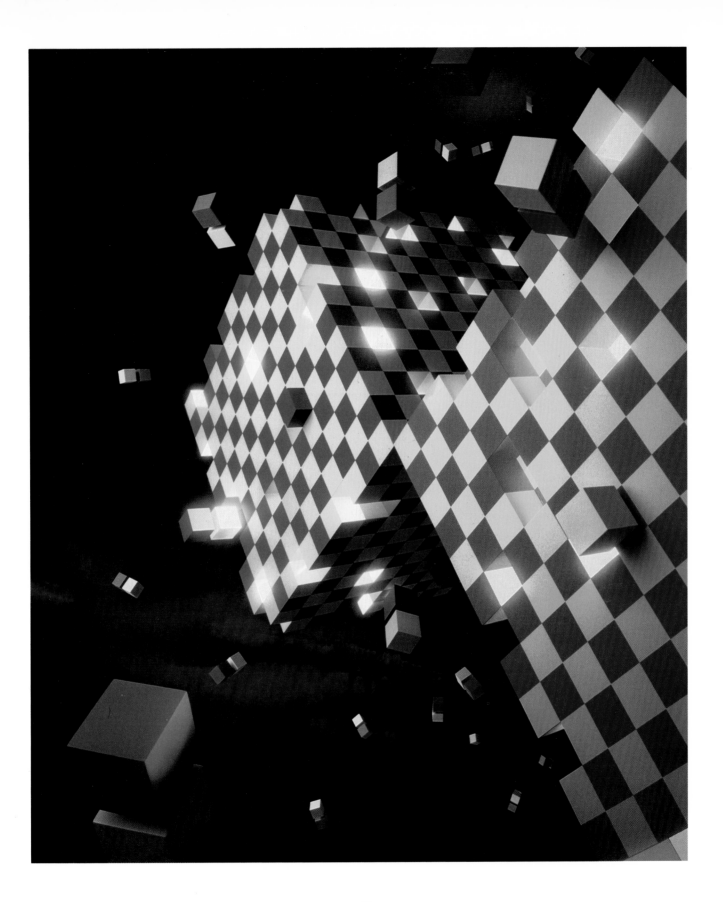

THE PRESSURE EXTRAPOLATION ❑ The theory illustrated here is that GM's research can be extrapolated to improve modern automotive exhaust systems by using catalytic converters to rid the environment of dangerous pollutants.

By using the sphere as the symbol of the molecular structure, we created a field of plastic balls of diminishing size, painted with a silver varnish, that represents the inert chemical reaction.

The yellow visual, illustrating the pressure of the catalytic converter, was created by a double exposure combining illustration and light effects.

The most difficult part of making this image was throwing the balls over the set and hoping they would stay in place.

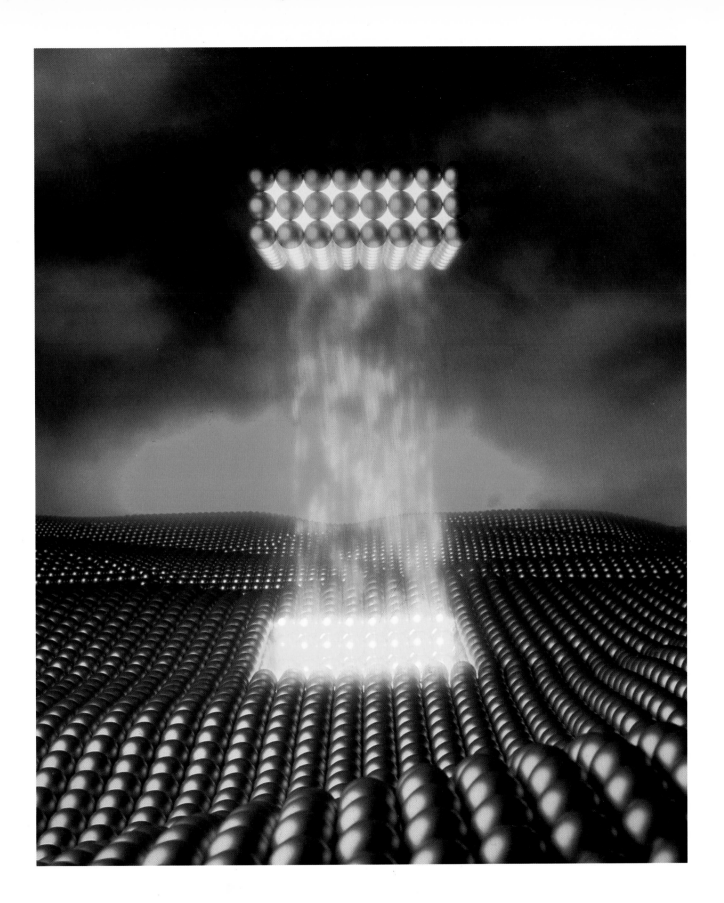

THE CLINICAL SPECTRUM ❏ The deliberate bright colors and futuristic design convey the excitement of an important development in GM's research—a noninvasive diagnostic technique that involves the use of lasers and infrared radiation to detect disease. On a previous assignment, I had worked with images of human cells that had been recorded by an electronic microscope, then digitized and computer-enhanced. I used those photographs as visual reference for the foreground model of a biological organism built of urethane foam and colored with unscientific gold and magenta light.

The curved grid creates a graphic frame for the spectrum and gives the image a sense of depth and dimension. To create the spectrum I used color gels over a negative film. I shot it with a fog filter, threw it out of focus to soften the overall feeling, and then double-exposed it, in registration, on the inside of the grid.

The most prominent design element is the human cloud form symbolizing the potential interaction of technology with people.

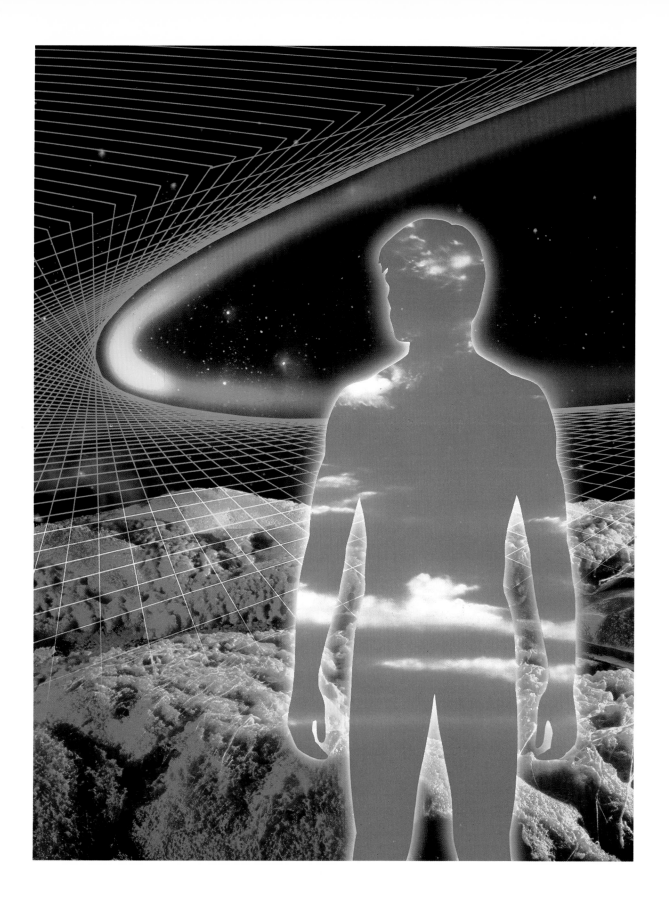

THE CONSTRAINED CURVE ❏ Industrial robot arms can repeat a well-defined motion with a high degree of accuracy. A mathematician at General Motors' research laboratories devised a simple, innovative way to relate the robot's motion to the path of time and establish accurate performance expectations without exceeding the robot's capabilities.

The technical problem in making this image was to re-create the perfectly smooth, exact mechanical movement of the robot's arm while showing a strong sense of perspective to establish that movement in space and time.

In a darkened studio, I placed a fast-firing strobe at the end of a swinging boom stand and photographed the repeating flashes with a zoom lens. After selecting the correct stroboscopic images to match the appropriate spheres, I assembled the elements into a single image against a gradated sky that was lighter in the center to further enhance the depth.

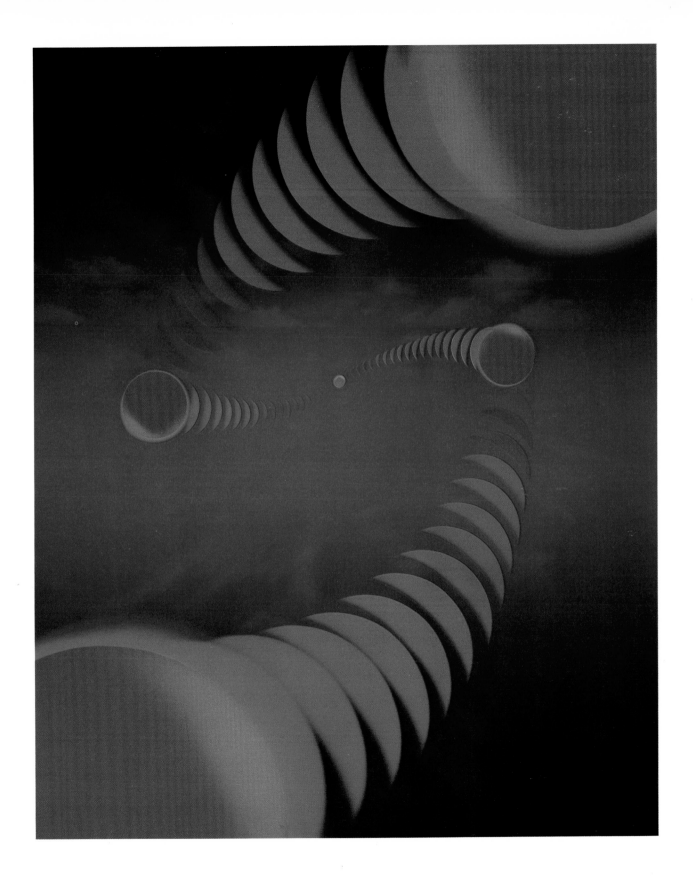

CARIBBEAN SKY ❑ I walked into my studio thinking about a sky I had photographed in the Caribbean. I wanted to do something dramatic with it. I looked through my props and found four rectangular columns.

Using a wide-angle lens and a beam to create a glow in the darkened sky, I played until I got just the image I wanted.

I don't do serious shooting while I'm on holiday. But I do take holidays in the studio when I play and make visuals for myself.

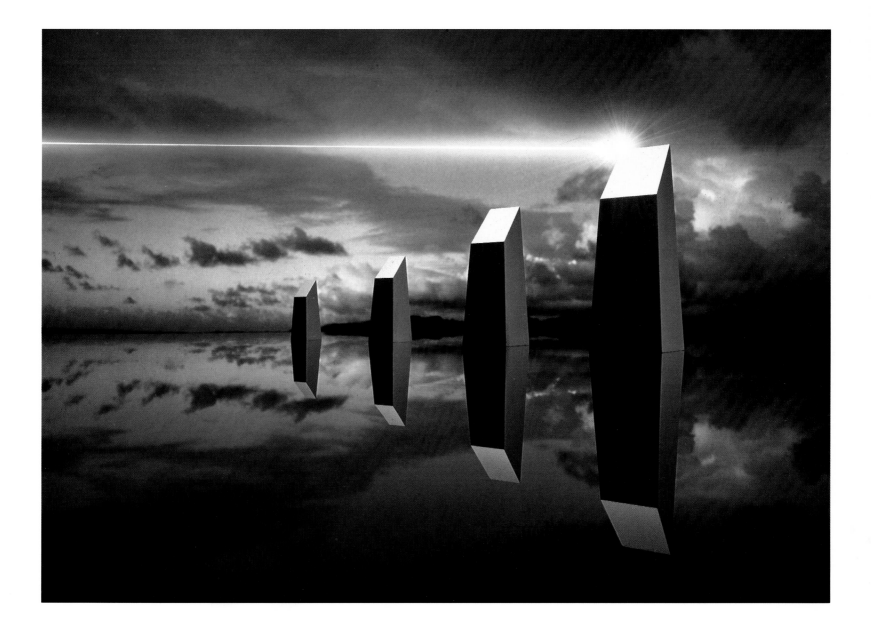

GEOGRAPHY ❏ In school I disliked Latin, chemistry, and algebra, but I was very good in geography. Geography allowed me to draw maps and involved perspective and shape, which already fascinated me.

This image is a full-scale interpretation of a microscopic picture of the grain structure of a piece of Kodak film. I constructed the shapes in decreasing sizes toward the horizon to create the illusion of extreme perspective.

When I look at this image, it reminds me of the days when all those words in school seemed so ephemeral compared to problems of mass and space, and I think how true it is that the more we change the more we stay the same.

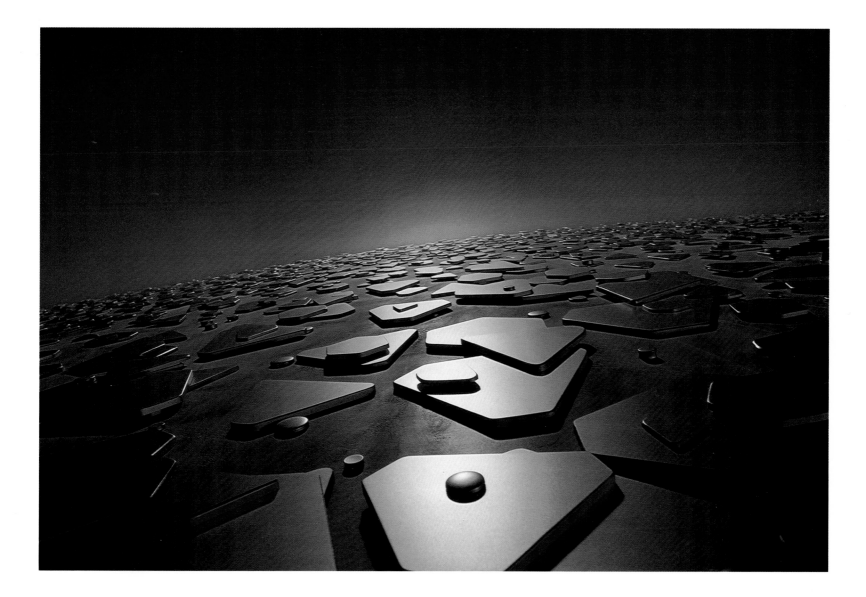

UNFINISHED SYMPHONY ❑ I was first given a drab black-and-white layout. Later, when I received the completed color comp, I saw the full sensitivity of the art director's concept.

The client was the Bose Corporation that designs and manufactures sophisticated acoustical equipment. I wasn't supposed to solve a problem. I was to execute a concept.

Often I describe an effect to an art director by way of sound. In this image I wanted to create a melody by delicately balancing the colors and shades on the sides of the cubes to give a lyrical feeling to the image.

This is a perfect example of an advertisement that didn't have to show "product" to be effective. It is a symphony of form and color, but it is a symphony that few heard because the ad never ran.

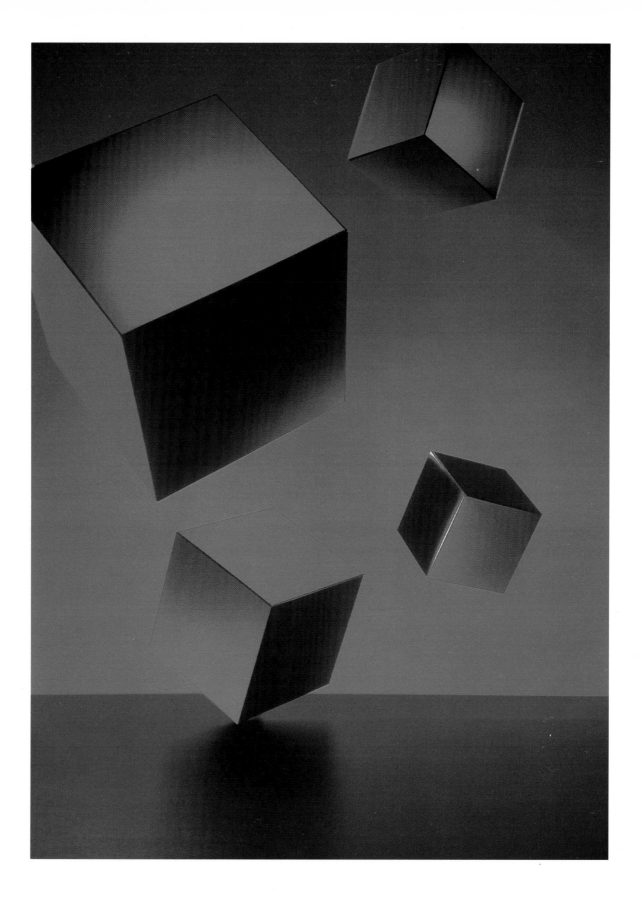

MY CLASSIC COKE ❑ So far my career has had four stages.

Initially, I'd shoot an assignment to the client's specifications, and after he had left the studio I'd do a variation of his concept, just for myself.

As time went on, and I gained experience and confidence, I showed the client my variation of his theme—but invariably it was rejected as too radical.

As more time went by, my variation was chosen by the client more often than it was not. Ultimately, clients came to me for what is now recognized as my "style."

In the mid-seventies my style wasn't totally formed. This cover for Coca-Cola's annual report was one of my first big jobs. The art director sent dozens of bottles of Coca-Cola to the studio. I stayed up until sunrise working on the design until it felt right. (That feeling of "rightness" is the foundation of my "style" today, just as it was then.)

The art director decided to run the photograph on the back cover as well as the front, creating the illusion that sent exactly the message the company wanted, "Coca-Cola forever." The marriage of design and image made this annual-report cover an award winner.

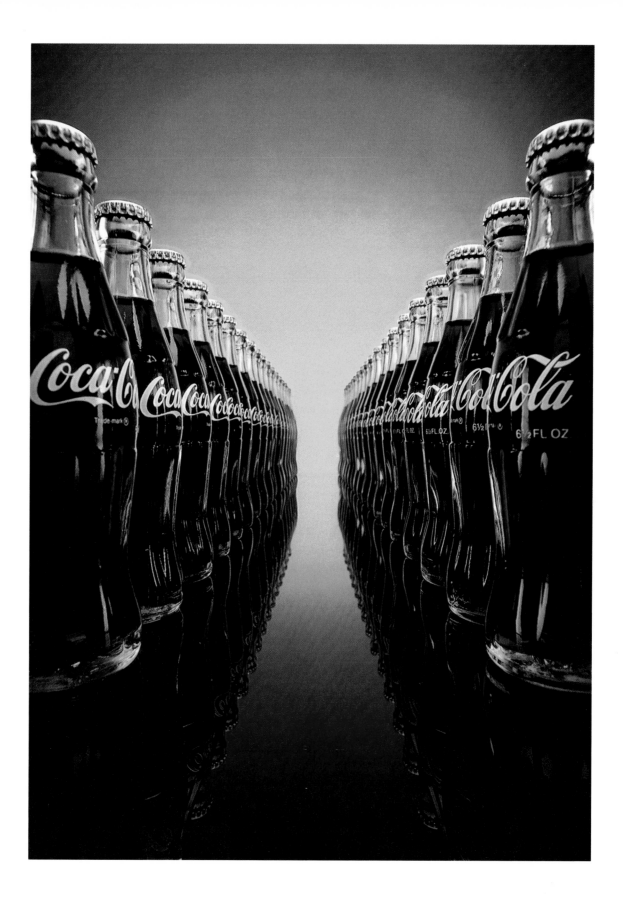

As a youngster growing up in Paris, I studied dance. Clearly I wasn't good enough to pursue it seriously, but that early training taught me to appreciate those rare exhilarating moments when great dancers become one with each other and the music they're interpreting.

The best moments in my work remind me of the best moments in dance. The exhilaration is the same when an art director and I, in sync, make a terrific image. Working with Dave Seager of National Geographic is a joyful collaboration that has produced some very good work.

My relationship with National Geographic began in the usual way, with a telephone call to the studio. Dave introduced himself, said he was working on a series of books, and made an appointment to meet me. When we met, he presented me with the concepts that he wanted illustrated. He told me to do whatever I wanted. At our second meeting, he rejected every sketch I showed him. At our third meeting, everything clicked.

Dave and I have been working together since 1984. His way of critiquing my work touches a note in me that rings right. Not that I always agree with what he says, but it always advances my thinking an extra step. The first book we worked on was *The Incredible Machine*—about the human body.

STAR MAN ❑ "The stuff of stars has come alive. Within our bodies course the same elements that flame in the stars. Whether the story of life is told by a theologian who believes that creation was an act of God, or by a scientist who theorizes that it was a consequence of chemistry and physics, the result is the same.

"The living beings of Earth are cosmic creatures, products of celestial events, atomic collisions, stellar explosions, molecular unions that were cataclysmic yet fortuitous. We are children of the universe."

After reading this quote from National Geographic's *The Incredible Machine*, I instantly visualized a translucent human form amid galaxies and stars, combined in a double exposure.

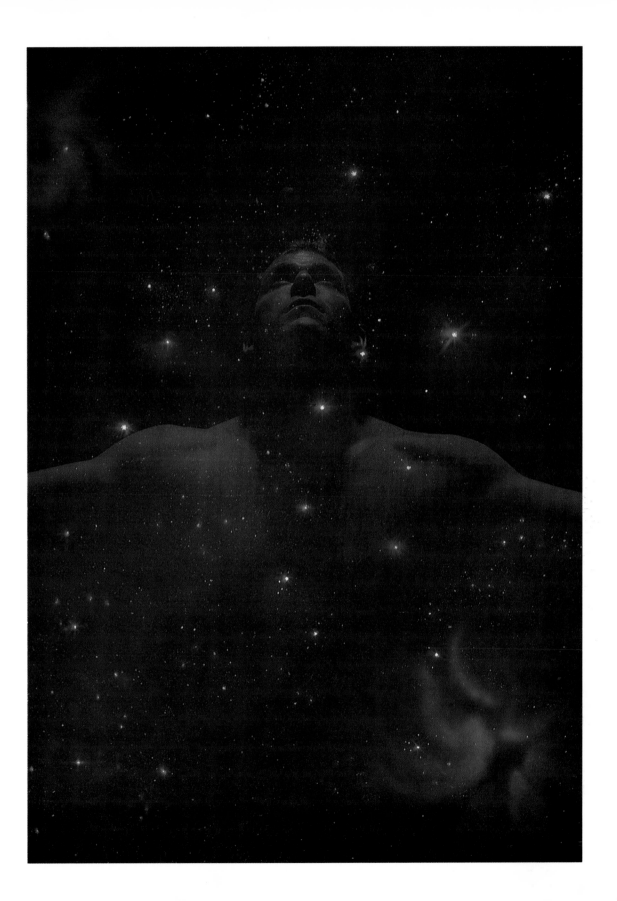

BIRTH ❏ To illustrate birth for National Geographic's book I needed a very pregnant woman and a very young baby. Finding the pregnant woman was easy. Finding a professional nine-week old baby was not.

When I finally did locate the baby, I asked his mother what time he took his nap. She hesitated. "Usually about one-thirty," she said. I suggested she bring the baby to the studio around noon to guarantee that by nap time he'd be fast asleep. At 1:30 the baby was laughing, and we were waiting. At 4:30 the baby was wide awake, and I was pacing. At 7:30 the baby fell asleep, and I caught the moment.

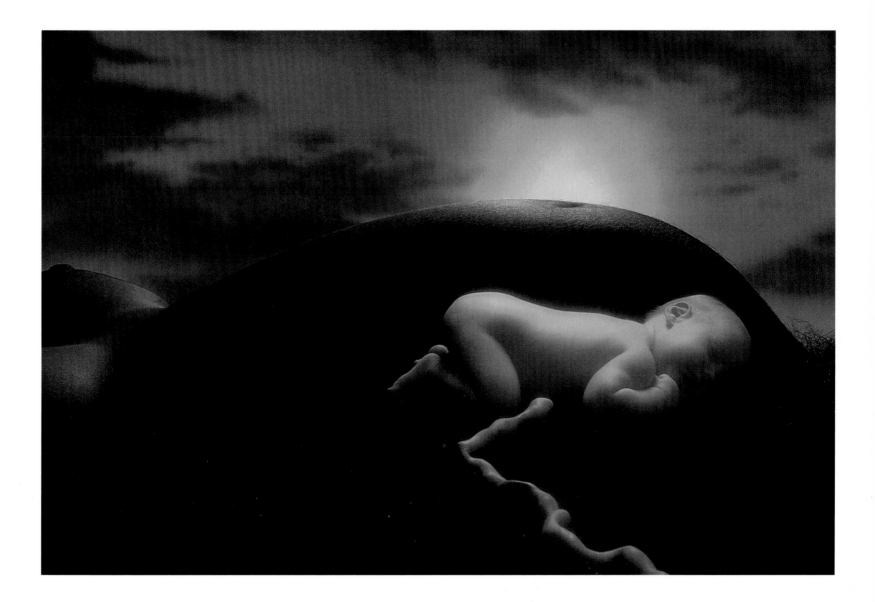

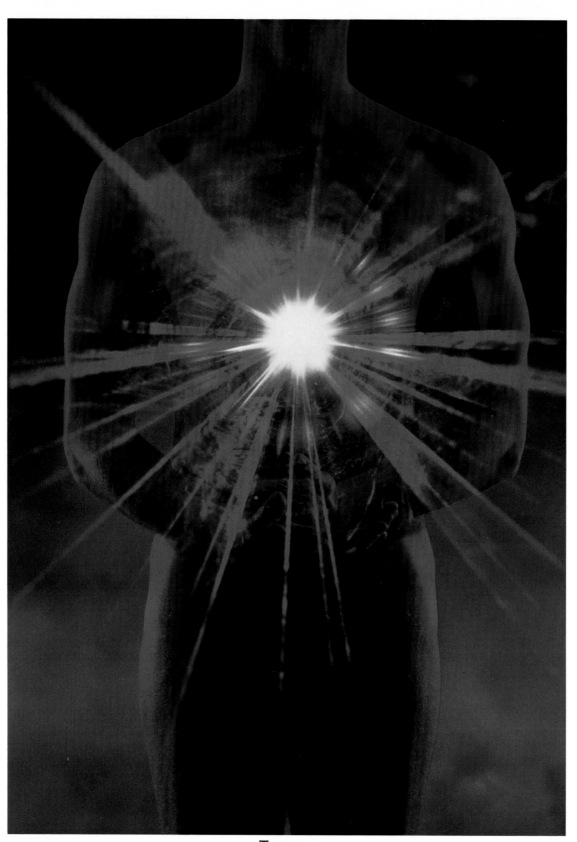

TORSO I

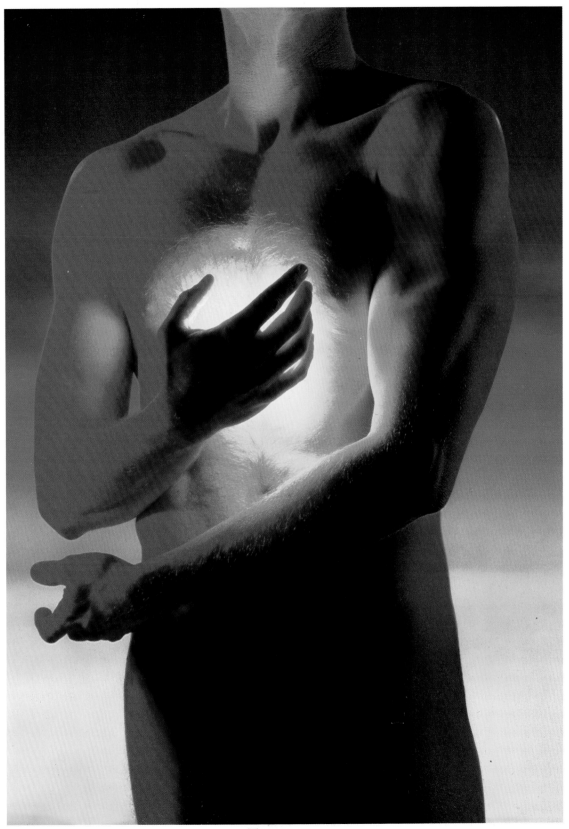

TORSO II

The second book Dave Seager and I worked on for National Geographic was called *Discoverers and Inventors, Changing Our World*, a book illustrating the history of technology. Since hands are people's most basic tool for shaping their environment, Dave and I agreed that the hand would be the key element that would conceptually connect every photograph in the book. I was thrilled because the hand is such a beautiful object—a masterpiece of invention. Every hand is the same machine working in a different way.

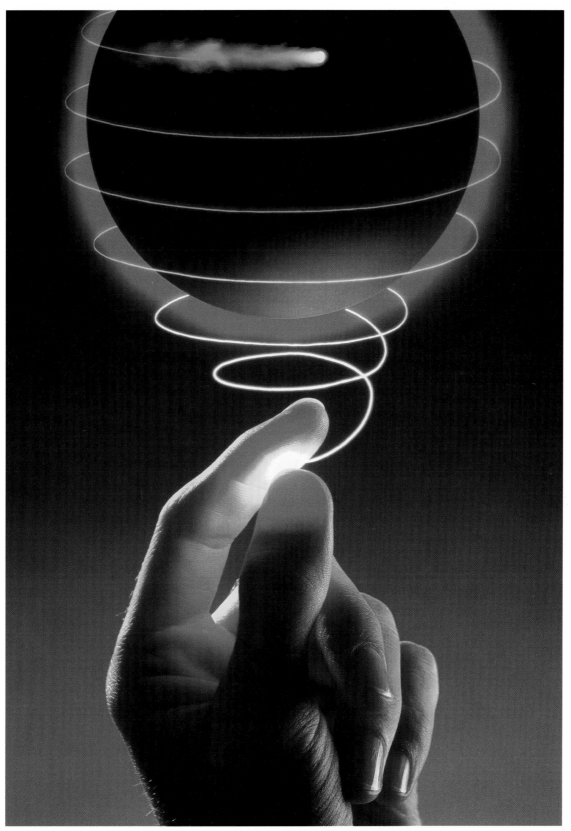

THE LONG DISTANCE MESSENGER

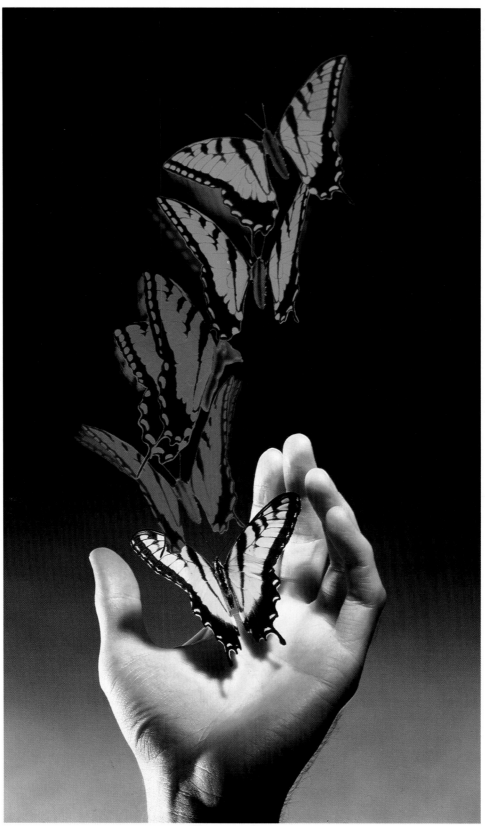

MOVING IMAGES

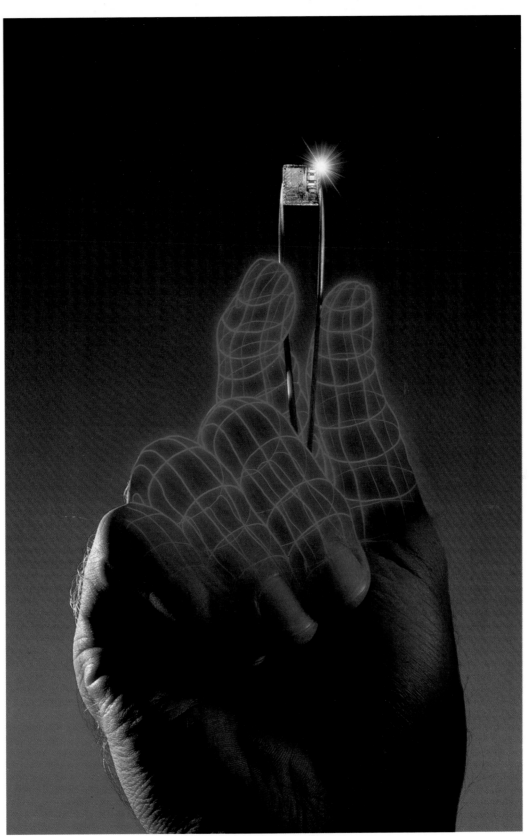

COMPUTERS AND CHIPS

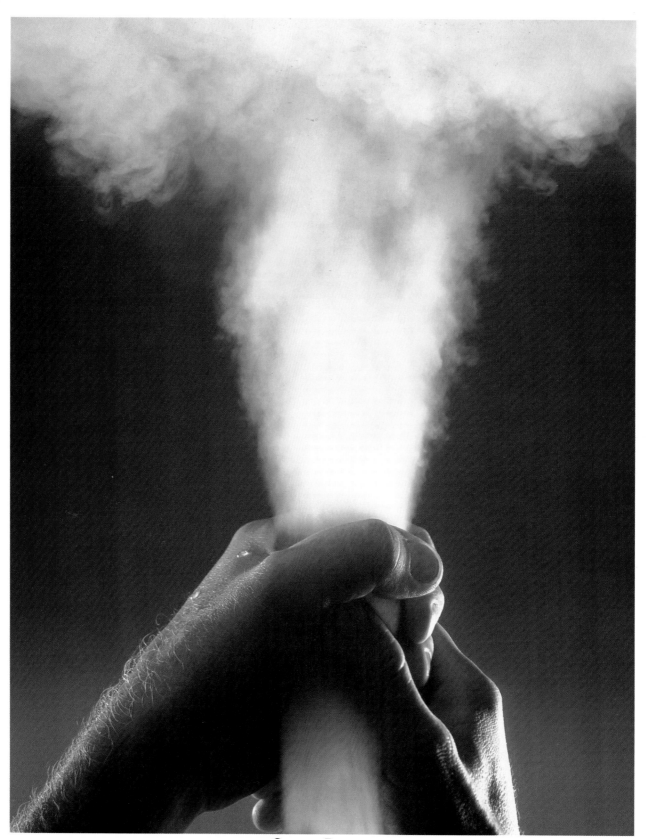

STEAM POWER

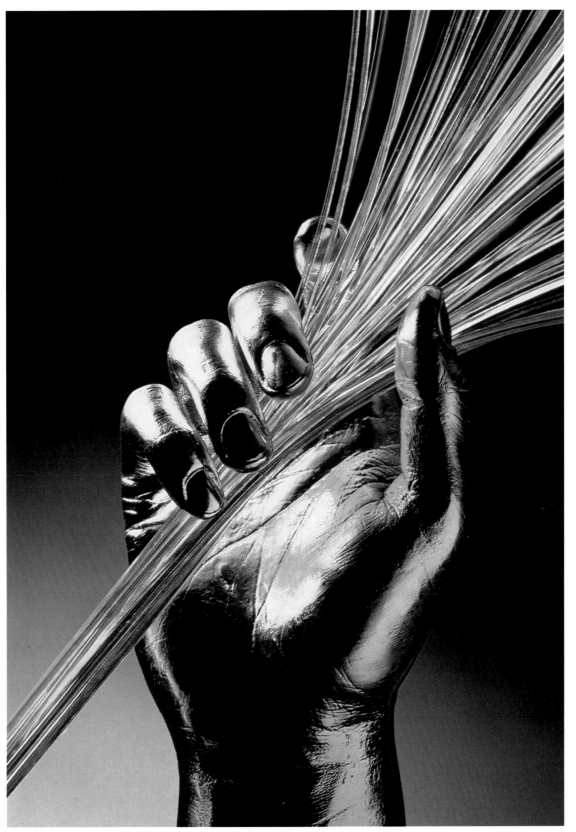

NEW MATERIALS AT HAND

HAMMERMILL PALETTE ❑ "Arty." "Colorful." "Thirty percent white." Those were the three directives the client gave me.

"Arty" because of the placement of the ad in such design-oriented magazines as *Graphis, Print,* and *Communication Arts.* "Colorful" because Hammermill wanted to demonstrate how well bright and primary colors print on its paper. And "thirty percent white" to show the quality of the paper itself.

In light of my profession, it would have been easy for me to use photographic paraphernalia. But since I have always secretly wanted to be a painter, I chose an artist's palette with brushes painting colorful streaks.

The white clouds not only provided the necessary setting to show the quality of the paper but also created an open, airy, and happy environment.

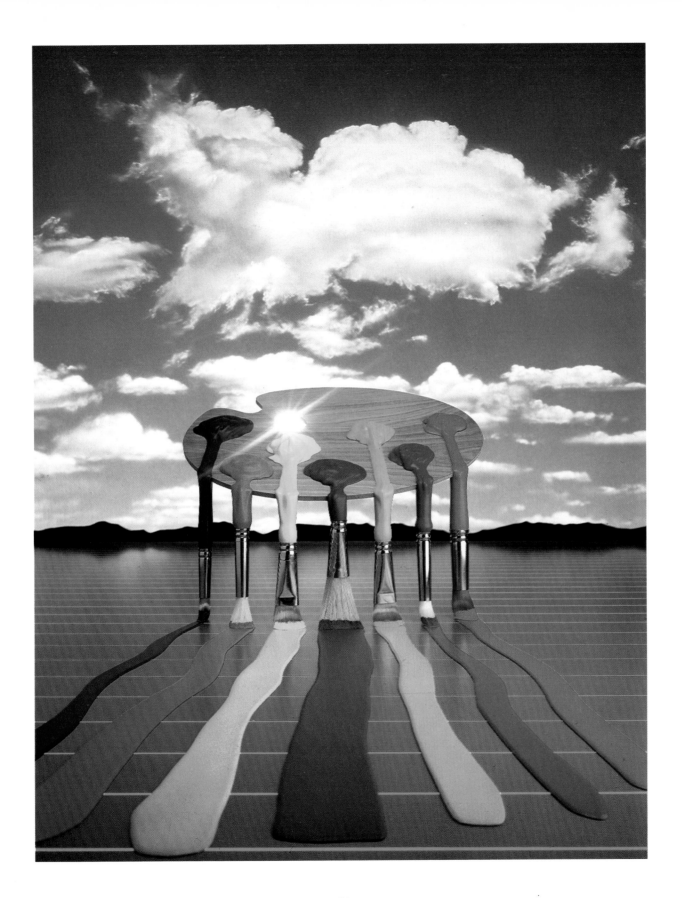

MISSING PIECES ❑ I can't remember a thing about this image except that it was an editorial assignment. I do remember that after I had the model built it took a short time to execute technically.

This image could apply to five or ten or even more stories, each sharing the same principle—"How things fit." Maybe this illustrated a story about people who are trying to fit into circumstances or places or a mold of what's expected of them. Or perhaps it was a highly technical story about designing a computer system and having all the pieces work perfectly.

It's fun for me to read an image as a consumer might and to know that the message does get through.

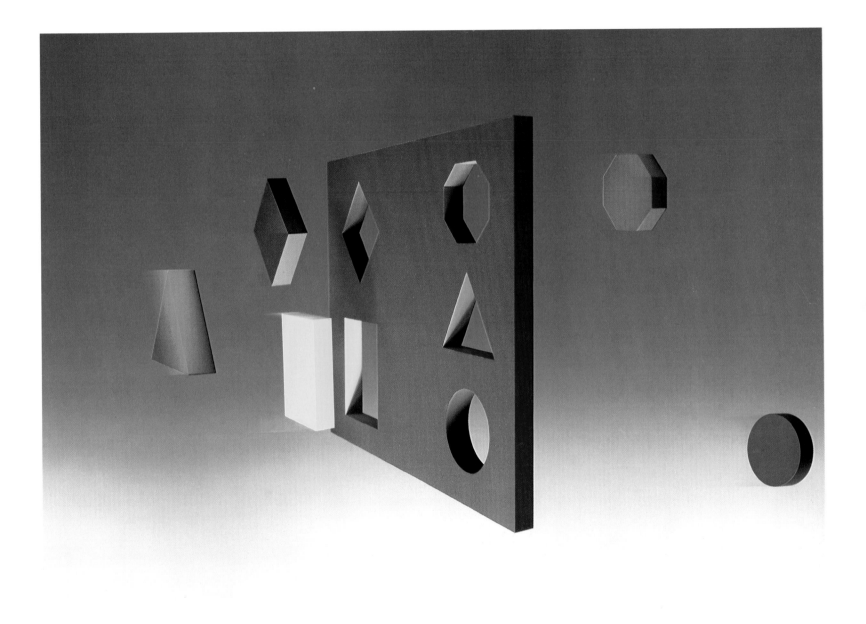

SHOE FETISH ❑ The assignment from *Penthouse* was to illustrate a fashion layout on men's shoes. The difficulty of the job was to create a bridge connecting women, who are the centerpiece of *Penthouse*'s appeal, and the men's shoes.

The trick in conceptualizing a photograph that works is to convert each element of the client's message into a readable symbol.

I started thinking about the shoes. Who designed them? The Japanese. That was my clue to the theme of the image. With tongue somewhat in cheek, I created a shrine to the shoes with a design element of a woman's form worshipping the rising sun. The shoes, scaled to read as graduated monoliths, complete the illustration.

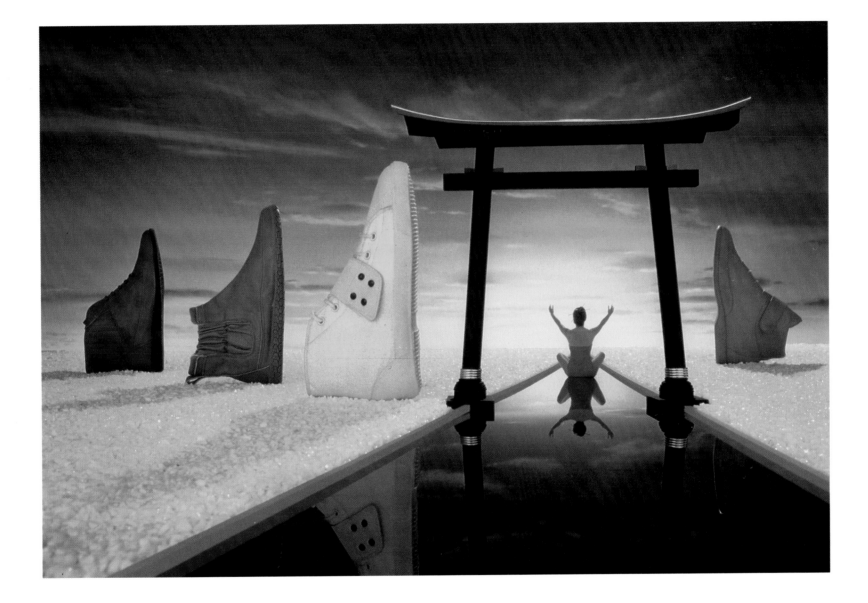

CINQ A SEPT ❏ Penthouse wanted to illustrate a story on cocktails.

The American tradition between five and seven is cocktails.

The French tradition of *cinq à sept* is being with one's "friend."

As a Russian raised in Paris and living in America, I combined all cultures and created this provocative image.

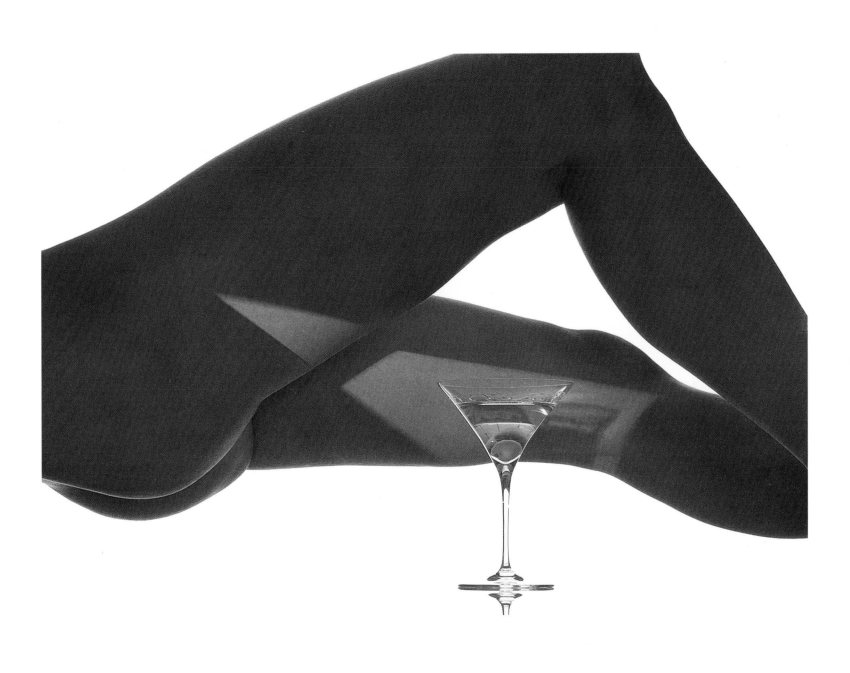

INSTANT FANTASY ❏ I was asked to design an image to be used in a special issue of *Zoom* magazine devoted to Polaroid.

Zoom is a high-key, provocatively designed European magazine with most of its readership in France, Italy, and England. I had *Zoom*'s readers in mind when I made this photograph. Since European markets are more receptive to "suggestive" images, I remembered "Cinq à Sept" and created the image of an illusive man who has just taken a Polaroid and is peeling away the layer of his fantasy. I added the double shadows to dramatize this illusion. The man's disappearing hand and the floating shadow were specifically added through masking techniques for *Zoom*'s photographic audience.

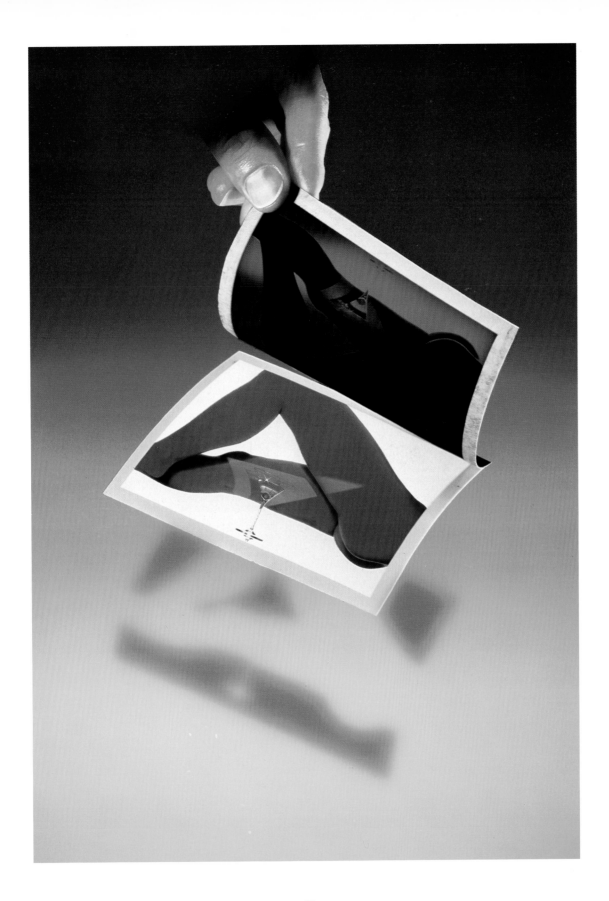

RUNNING TECHNOLOGY ❏ The human brain is the world's most sophisticated moving-picture camera. When we see a man running on the street, for example, our brains automatically interpret and record the moving image. If you were to use a still camera to photograph that same man, you'd either stop his action in the frame or blur the whole figure. To dramatically interpret his speed you would combine the blur with the stop action and produce speed lines, not to create a new reality, but to enhance the existing one.

"The Runner" was commissioned by Panasonic for a poster for the Millrose Games, the track and field events that preselect the athletes for the Summer Olympics. The concept was to promote Panasonic's participation in the Olympics and to imply the harmony of people and technology.

This was a difficult job, but I like the shot, and I think it's a good example of visual perception and the manipulation of time and space to communicate a message.

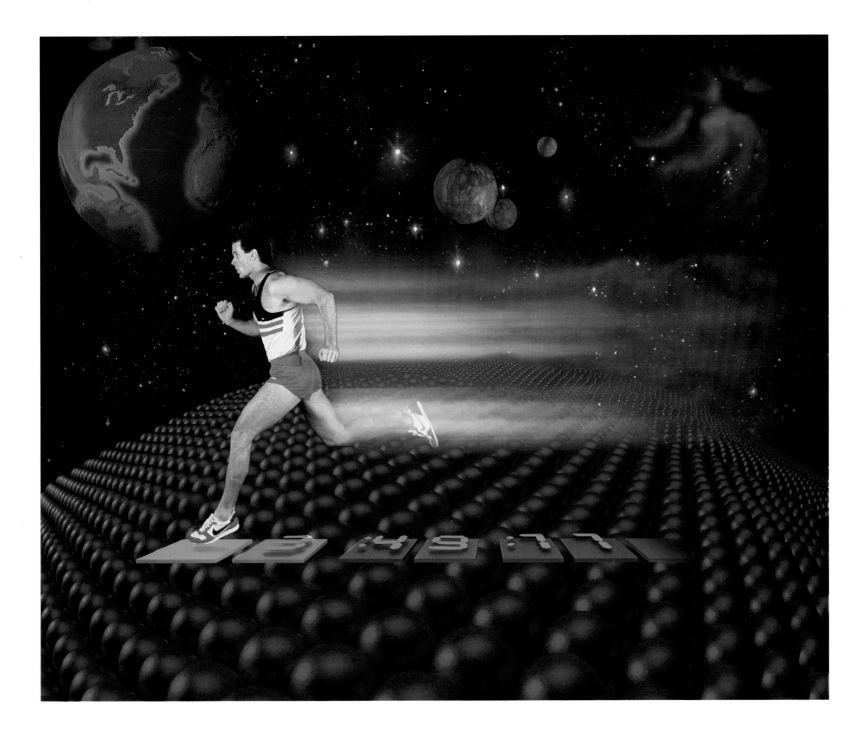

THE RING OF HEALTH ❏ Over the years, I have assembled a file of ideas and elements, some in rough form, some ready to be used. I also keep a wall of my studio covered with tearsheets so when clients and I are working on concepts for an image we have visual reference points. It is easier to see an effect than to describe it, and it's especially helpful if the client can have a number of alternatives to choose from.

One of the ideas that I had been playing with was a large turntable, rigged with a light, to create a graceful elipse. If instead I had used a tool like a French curve, I would get an effect that was too "mechanical." I wanted to create reality in an unreal way. Then came Allegheny General.

This was to be a "visionary" ad for a hospital in Pittsburgh . . . no stethoscopes, no scrubs, no nurses, just a symbolic image of people involved with people.

Keeping multiple elements in my head and dealing them in the right combination at the right moment, is very much like playing with a deck of cards. Each element has a different value depending on the game you play.

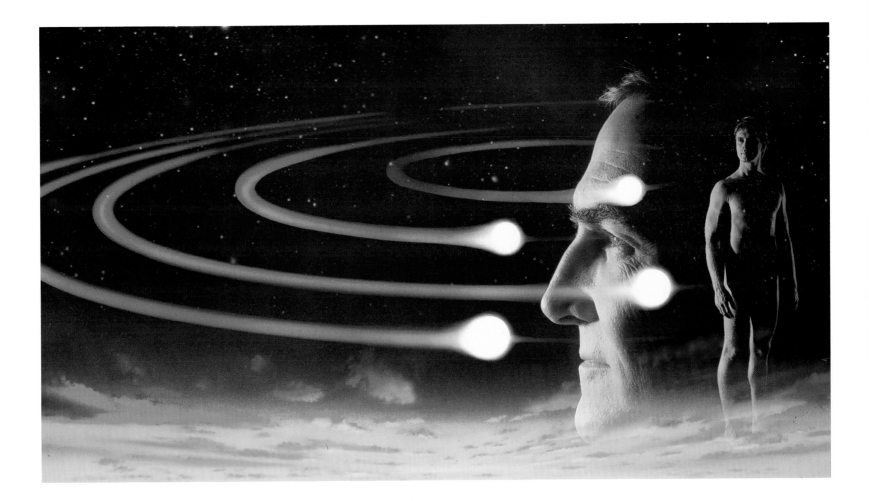

RED FREE FALL ❑ This is one of my all-time favorite shots which I created as a cover for *Science Digest*.

The sense of weightless tranquility combined with the passionate red color simulates energy. I look at "Red Free Fall," and even though I know it's an illusion, I hear music accompanying the perfect harmony of the floating figures.

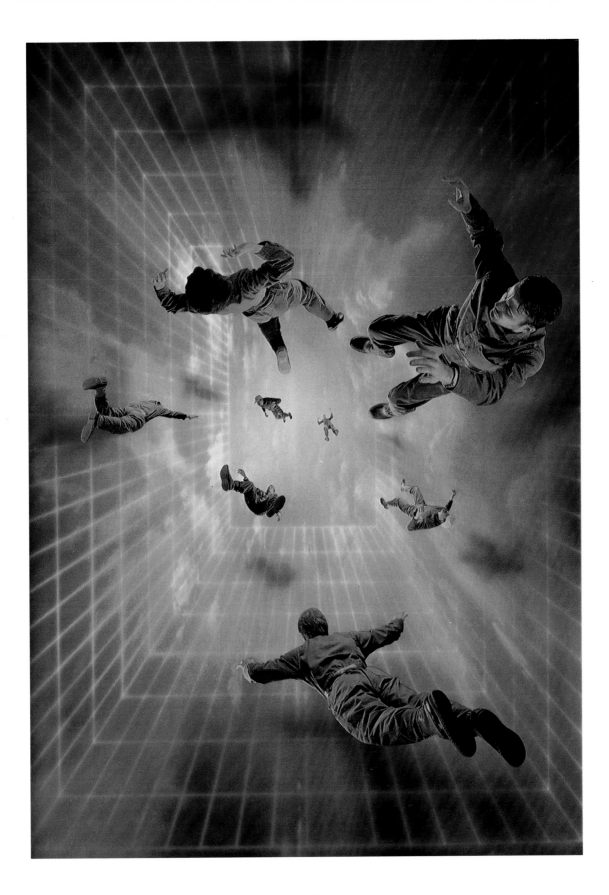

PORTRAITS ❏ Portraiture with a twist was something new for me.

A designer called and said he was organizing a media event to promote his agency and had selected several artists, illustrators, and photographers to create visuals celebrating his company, its people, and its work. I chose the people. My idea was to interview each of my subjects and then embroider his or her personal possessions, idiosyncratic paraphernalia, as well as the physical image into a unique tapestry of his or her personality.

Using multiple dimensions, double exposures, graphs, and illustration on brightly colored backgrounds, I created these photographic montages.

A modification of this style of portraiture became for me an exciting concept for corporate application.

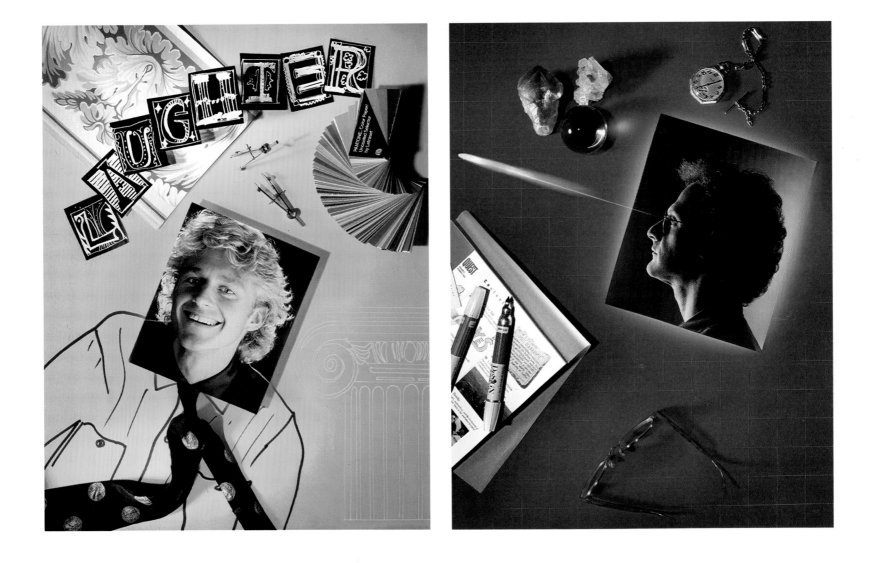

THE BLUE DROP ❏ I did this shot for a pharmaceutical company that produces liquids for cleaning contact lenses.

I combined the concept of the purity of clear water with a pure blue sky. The ring that the drop creates as it falls into the water is the shape of the lens. The field of fluid circles subliminally reminds the consumer of the soft contact lenses.

I made the image horizontal because it feels more comfortable that way. A vertical format would have been too restrictive and would have created the uncomfortable illusion of the drop falling quickly, rather than softly, into the water.

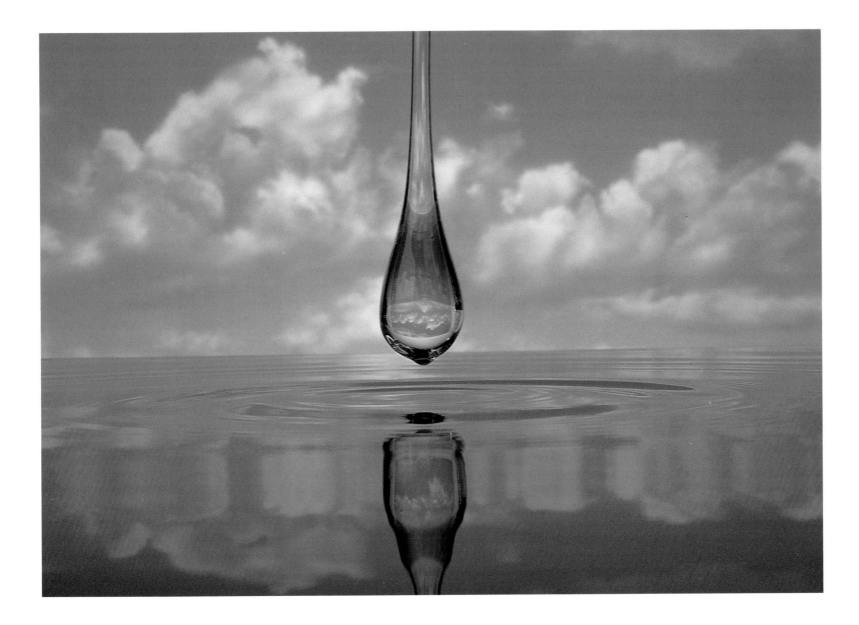

LAVENDER FIELD ❏ This trade ad was another in a series commissioned by the manufacturer of soft contact lenses. The ad is a departure from the more traditional medical advertising because of its cosmetic as well as its technical orientation.

Whereas the ad "Blue Drop" illustrated the fluid that washes the lenses, the message of "Lavender Field" was the perfect design of the lens.

The focus of attention are the eyes. No android for this ad. The model's visual appeal, the beam of light coming from the eye, and the use of a lavender field came together in this aesthetically compelling image.

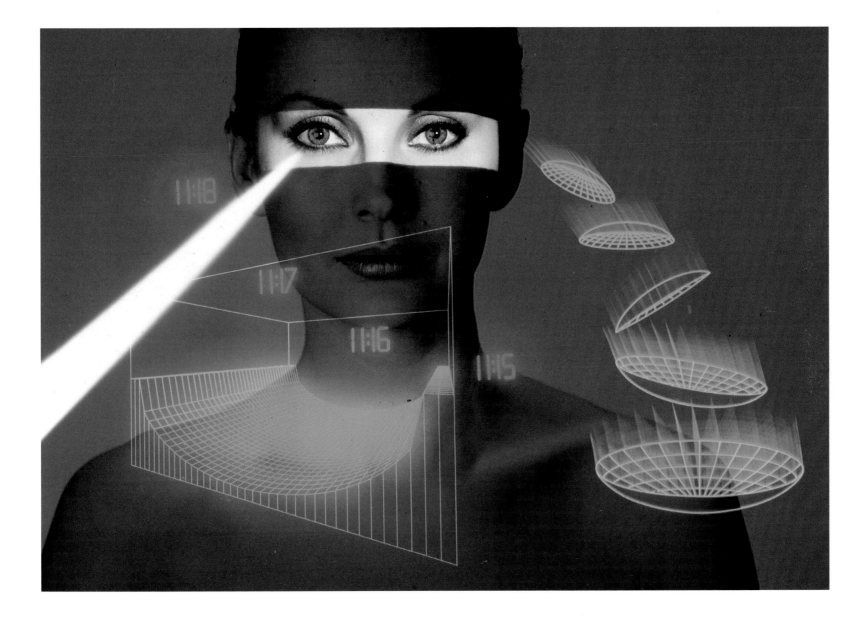

SAND CASTLES ❑ Many people build their financial futures on shaky ground. My client, a life-insurance company, wanted to emphasize the point that even the most beautiful castle on the beach could be washed away with the changing of the financial tide.

My problem was to create a most beautiful castle, one foot high and four feet long to fit the layout they gave me. My research took me to the library where I found images of award-winning sand castles. I then contacted my model maker, whose extraordinary craftsmanship made this image come to life.

Following my habit of playing with a concept even after a job is completed, I added a child's brightly colored pail and shovel, and I told a completely different story.

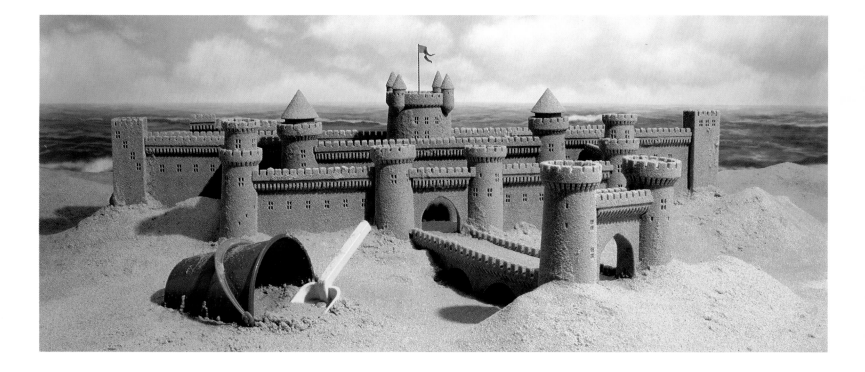

LIFE FROM ZERO ❑ Monarch Life, an insurance company, was offering a new investment option, Zero Coupon Bonds, that guaranteed a high return and maximum safety if held to maturity.

I was given a tight layout for this trade ad. Perfectly symmetrical eggs were required. Nature is not perfect. But a model maker can come close.

We designed the eggs proportionately to the size of the chicks and cut one shell at the top so we could place a chick inside. But our model refused to stay put. A baby chick doesn't take direction well.

I kept the background dark and lit the set from above to emphasize the roundness of the egg and subliminally reminded the audience of the number zero.

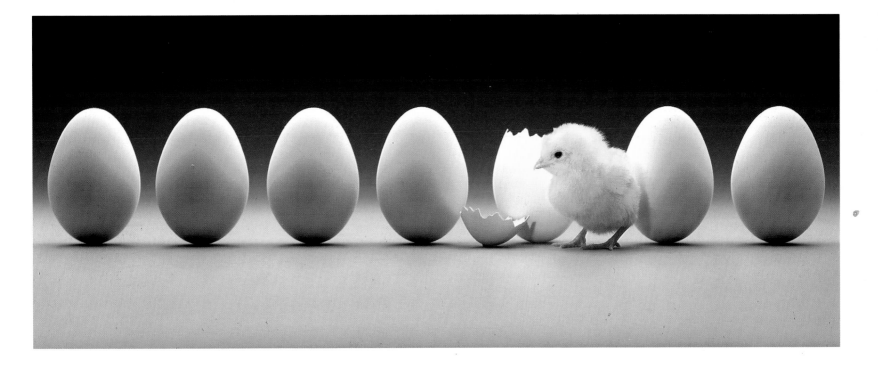

CHICKS AND EGGS ❑ This is one of my early images. It was the first time I used a multiplicity of objects going toward infinity.

I was just starting out in a small studio in New York. In the same building there was a manufacturer of bottle caps. One morning as I came to work, I saw in the lobby boxes and boxes of discarded caps. I picked one out of an open box and thought it was a terrific shape. To me it looked just like an egg. I took all the boxes upstairs.

Then I went and bought eggshell-colored paint. I sprayed thousands of the caps and laid them next to one another on a lightbox. Next I went to a pet store and bought some baby chicks. I put them on the lightbox—and voilà!

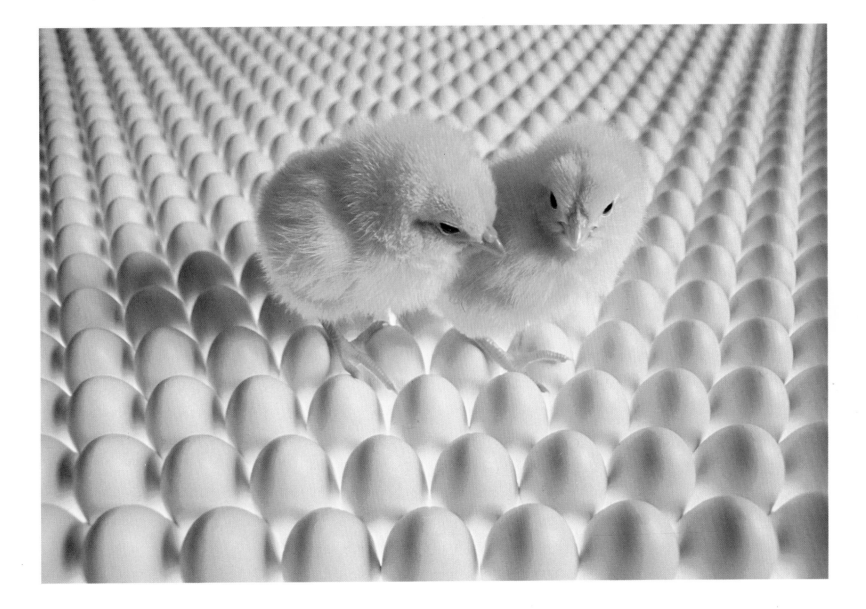

BABY TALK ❏ Both my son Sasha and my daughter Sonya were picture perfect when they were born. So when I started working with *American Baby,* it seemed a natural extension of where I was in my own life.

This photograph was probably the easiest shot I ever did. The actual shooting took less than ten minutes. The planning and organization took considerably longer.

My assistants attached pillows to white seamless paper on the studio floor. The lights were set and tested the night before. Each infant was accompanied by a parent who on signal put his or her baby on a pillow. When the babies were all in place, everyone in the studio applauded and cheered. The babies were so surprised that for just a moment I held their attention and caught this image.

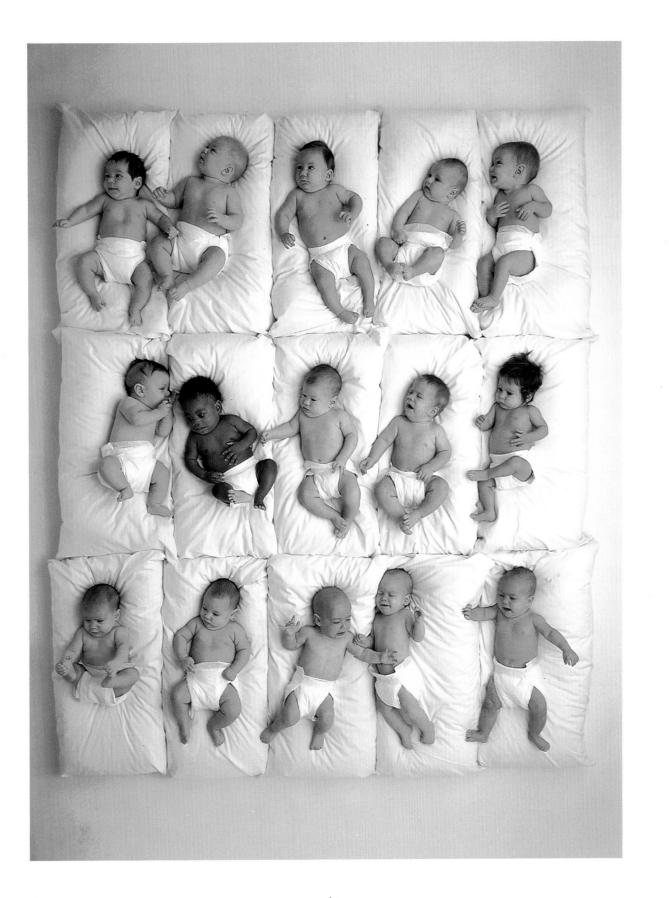

THE FIRST MEAL ❏ I still have tender thoughts when I look at this image. I had done it for myself but when a friend, an interior designer, was looking for an image to use at a seminar on restaurant design, she saw this photograph in my files and said, "That's exactly the feeling that I want my work to reflect: a warm environment, excellent food, and guaranteed service."

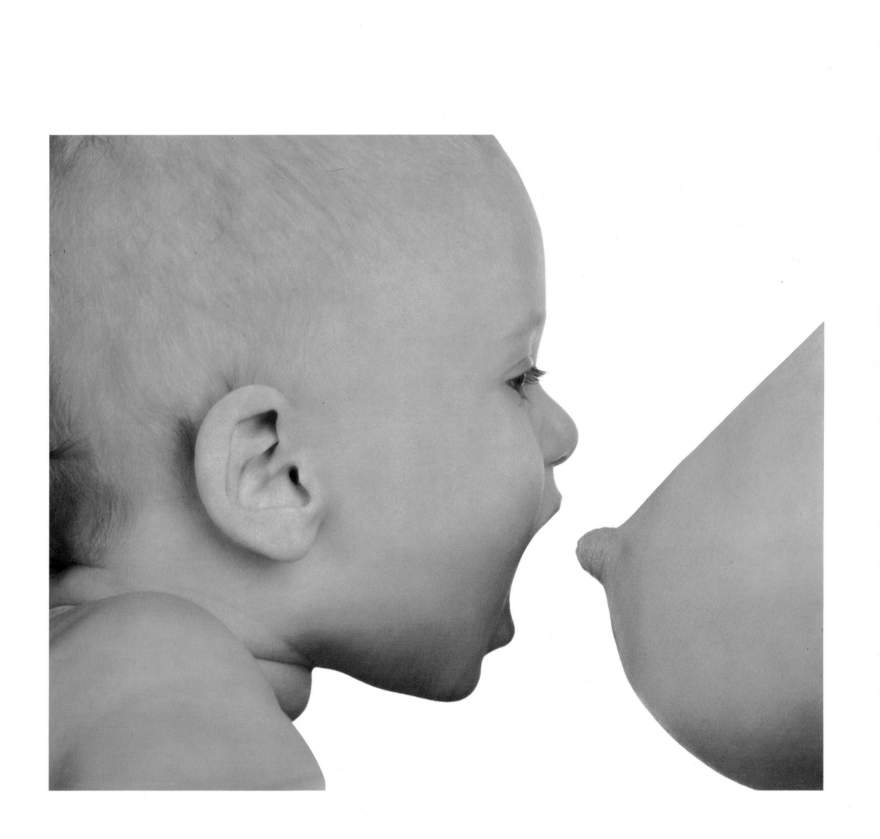

AT&T WANTS YOU ❑ When I'm asked to create an image for an advertiser, I always ask the client two questions: "What do you want to say?" and "To whom do you want to say it?"

In this case, AT&T wanted to create a recruitment ad for university students that would make a global statement about the company's people, its future, and its technical orientation.

The top half of the image is two line drawings of the world and a network system combined and colored with gels to illustrate the global scope of the client's technology. For the bottom half, I used generically designed plaster models of men and women standing on plastic replicas of telephone buttons connected to the vanishing point by red rods. The perspective leads the eye to the rising sun, which symbolizes the future success that every graduating student is seeking.

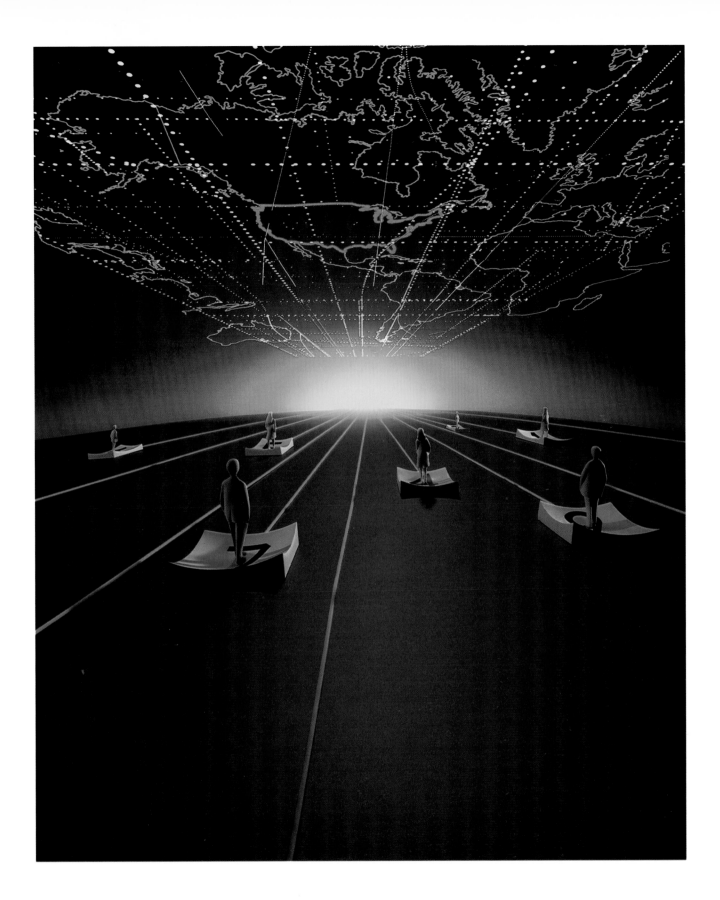

There are no "tricks" involved in a "straight" image. The photographer has to depend on good composition and light. Frequently, that's what makes a "simple" shot so difficult.

The art director with whom I worked on this series of cosmetic ads never goes in an expected direction. He knows exactly what he likes. But he doesn't always know what he likes until he sees it. That's where I come in. Sometimes we don't see eye to eye . . . so I do it his way. Our work is always predictably unpredictable.

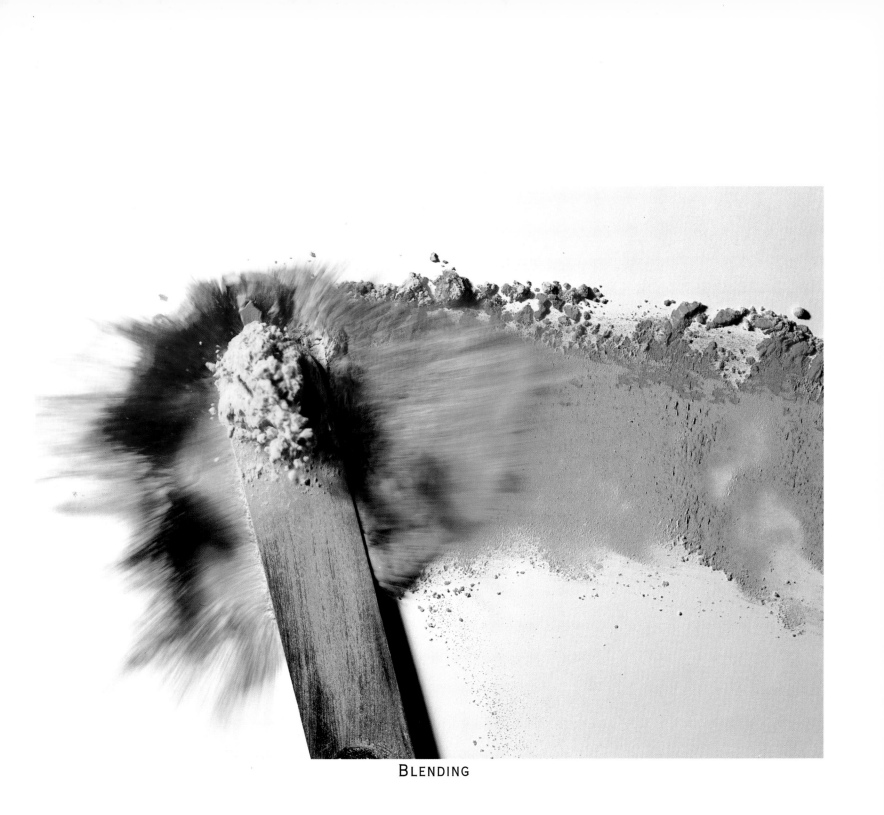

BLENDING

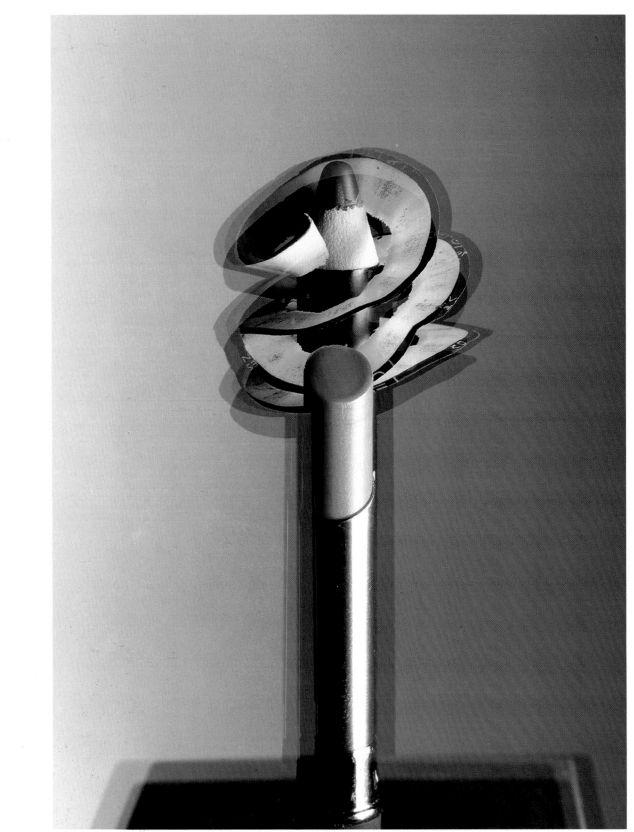

COSMETIC APPEAL I

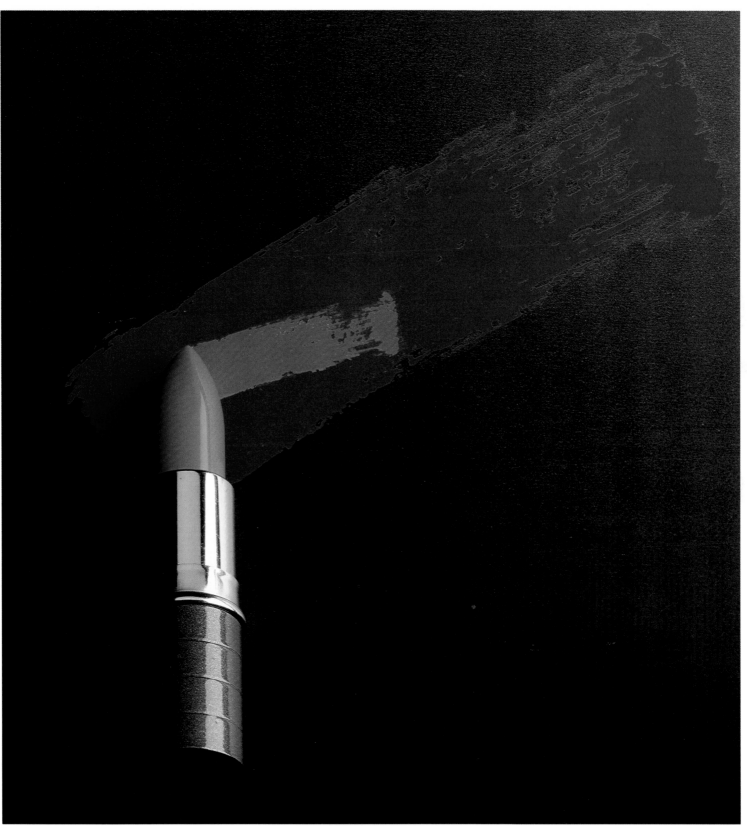

COSMETIC APPEAL II

Since 1984 was an election year, Frank B. Hall, one of the world's largest insurance companies, wanted its annual report to be a bold and dramatic departure from the more standard financial brochures. Featuring articles and interviews by noted authorities in politics, economics, business, and academics, its brochure addressed the most controversial and important issues of the upcoming national elections.

POLITICS UNDERCOVER ❏ As an introduction to the political content, the visual I designed for the cover combined the strong graphics of the American flag with miniature models of the Capitol.

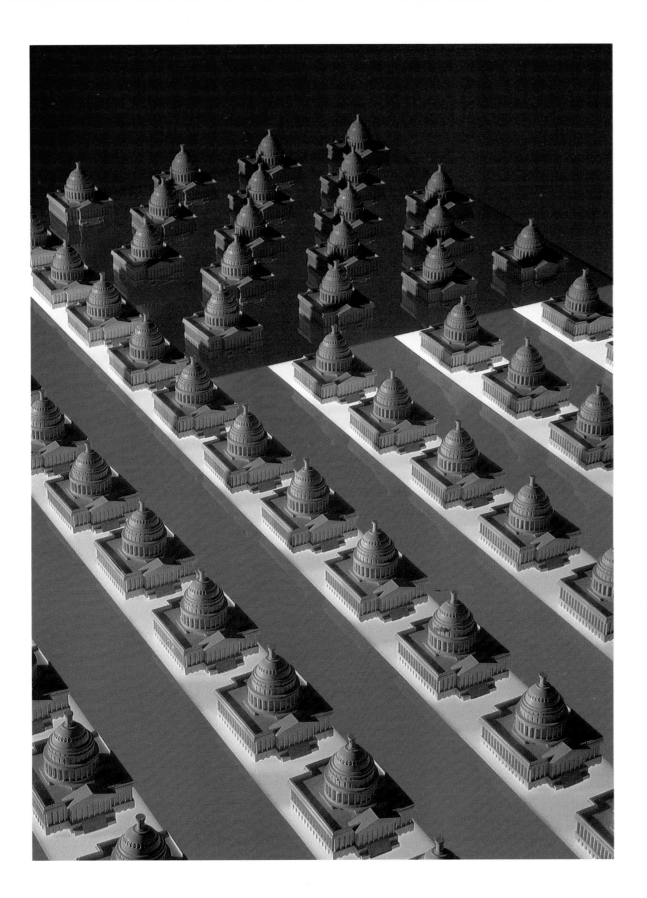

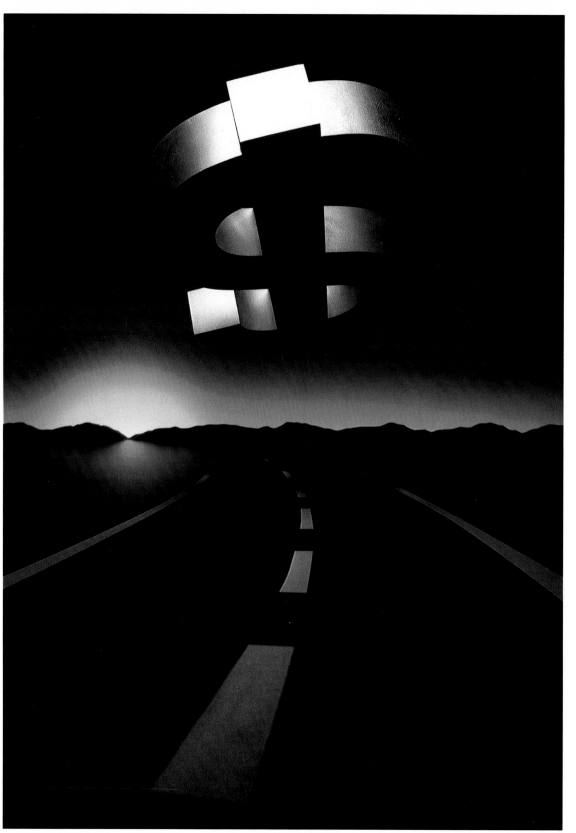

MONEY SUPPLY

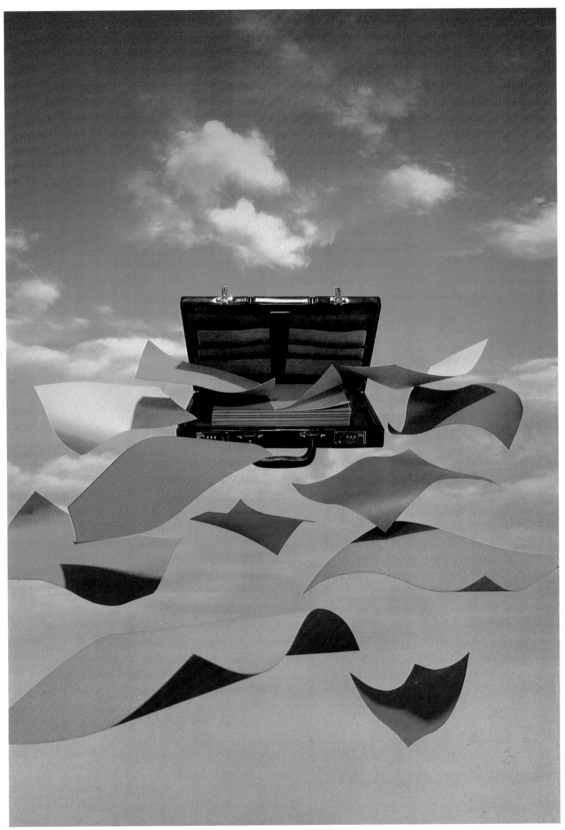

POLICIES

THE BALANCE OF POWER ❏ For interviews with Arthur Schlesinger, Jr., and James Buckley I was to illustrate the concept of national defense and the nuclear-arms issue.

I visualized this concept as a precarious balancing act between the East and the West. I thought of the balance of power as a tactical game and used a chessboard, with miniature missile heads colored blue and red, resting on scale models of rockets to dramatize the point. The lightning is the primary light source that heightens the energy of the image.

This game is played under an ominous sky that canopies the players with a foreboding of danger.

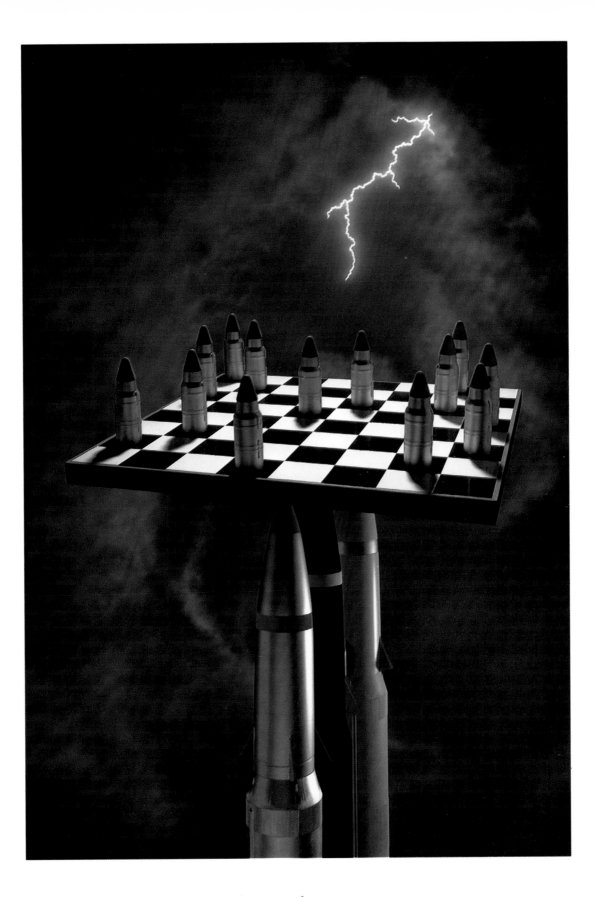

INTERNATIONAL TRADE ❑ I wanted to reduce the complex issues of international trade to a single common denominator. I rejected the use of a map or a global field for this illustration and decided to create a hallway with open doors and flying packages to symbolize open trade and commerce.

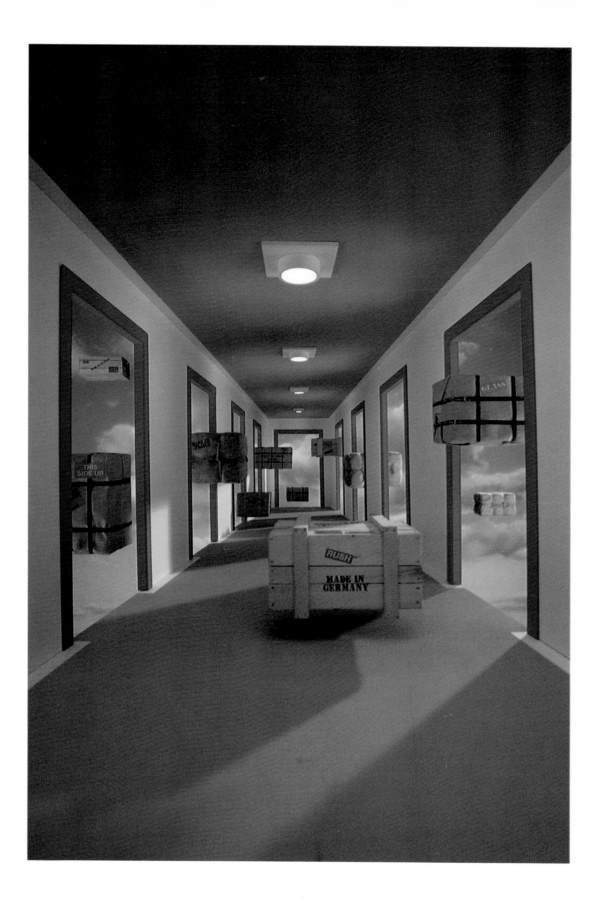

GOVERNMENT SPENDING ❑ The Capitol is as central to illustrating this concept as is the government that manages the federal budget. The green spheres are a slightly whimsical expression of the monies that like the most delicate bubbles float beyond control and vanish into thin air.

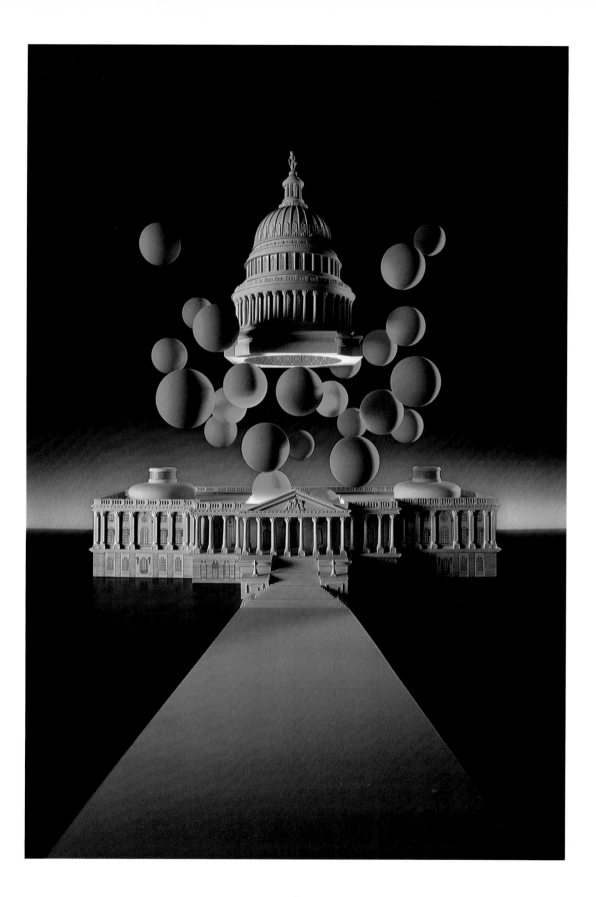

CHAIRMAN OF THE BOARD ❏ A productive business is an efficient business. To be efficient the perfect plan must be effected. The plan begins with the Chairman of the Board.

By using the sphere as a common symbol of unity of corporate purpose conceived at the boardroom table and leaving the factory door, I created the direct link between the conception and implementation of products and services responsible for business productivity.

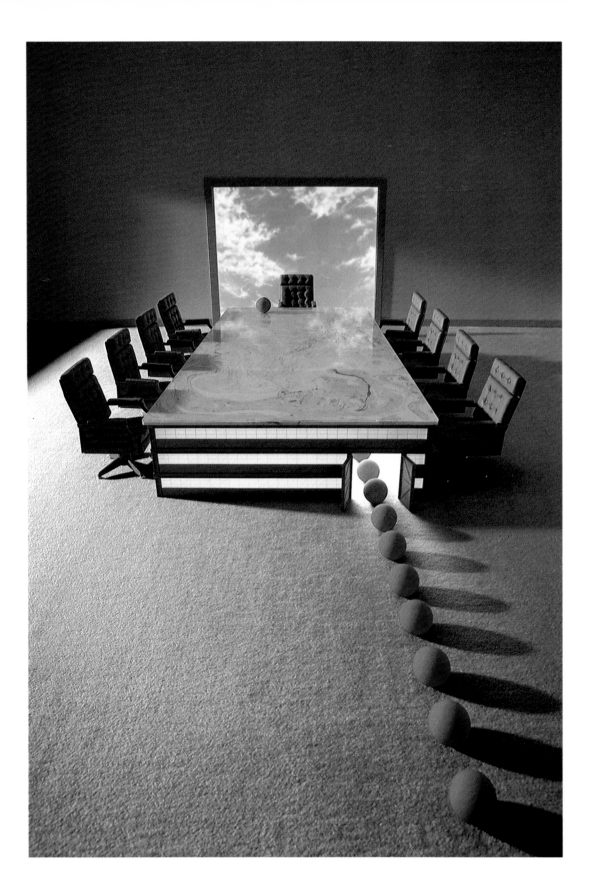

POLLUTION ❏ This illustration was used as a symbol of environmental issues.

I wanted the image to be clean even though I was illustrating such environmental problems as underground water pollution, oil spills, and acid rain.

The bright red oil barrels floating from a clear blue sky onto a pristine beach give warning of the danger that is present but as yet unseen.

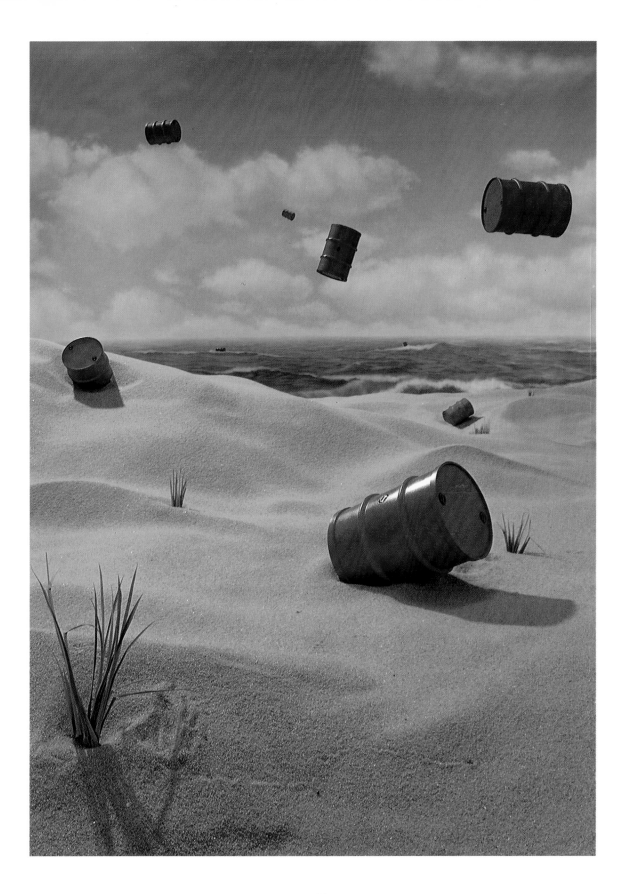

HEAVEN WAITS ❑ All the client told me was to create a stairway to heaven and leave enough space for the title of the magazine. That was it.

I did the shot in half a day. Everything fell into place immediately. The stairway appears accessible, wide at the base and narrowing at the top to give a sense of upward direction. The stairway is a welcoming climb away from the abyss to a happy sky.

The simplicity of design worked to convey a complex message of eternal peace.

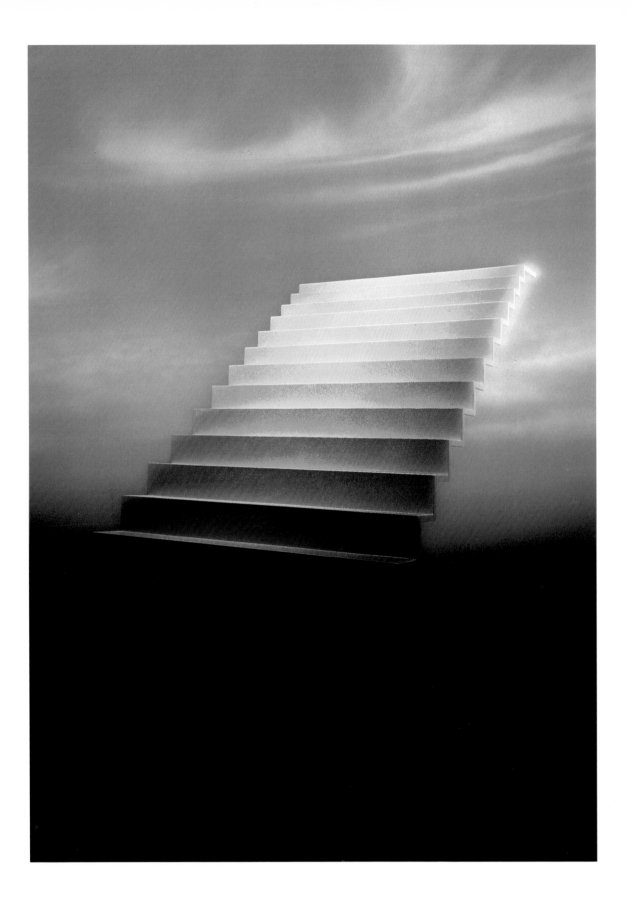

PLAY ON LIGHT ❏ I had just visited The Metropolitan Museum of Art. It was a bright sunny day, and the light that came into the giant halls of the Egyptian Wing created beautiful shadows. I had the shapes of the ancient artifacts and the impression of the dramatic shadows in my mind when I returned to the studio. (Actually, I had gone to the museum many times to look at those shadows so I could interpret them photographically.)

I chose a variety of shapes and balanced them with a larger sphere at the base of the image, but the shapes were really secondary to my desire to play with the light as an enhancing element.

I hoped this play on light would be the answer to a specific assignment I was working on, but it wasn't, and I just didn't want to file it away and wait, so I did it for myself.

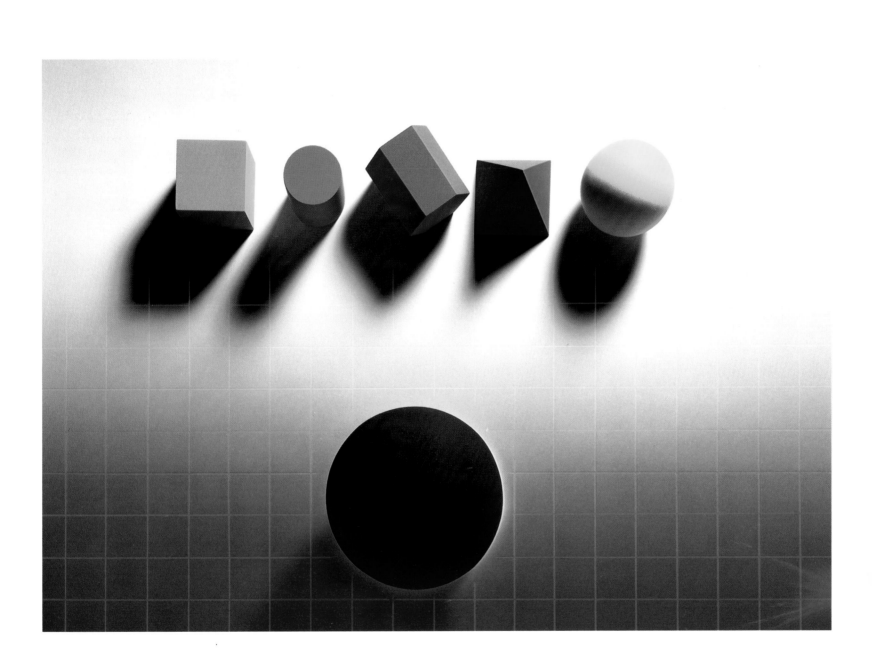

SPHERES OF INFLUENCE ❏ The shapes I use and the way I place those shapes is instinctive. Every shape has a sound. The sphere whispers. A cube sounds like a drum. A sphere is predictable because it's the same from every direction. Lighting a sphere is easier than lighting a cube because it carries light beautifully as it moves silently through the frame's space. Ultimately, it's the sound of the shape that dictates how I'll use it. I guess that's what I mean by "composing an image."

I created this image for Dolisos, a French company that manufactures and distributes homeopathic medicine. Homeopathy, as I learned, is based on the theory that a given disease may be cured with minute doses of a medicinal substance that when administered to a healthy person would produce symptoms of that disease. The most important elements in this image are the spheres, each representing a perfectly round sugar pill coated with an infinitesimal amount of medication.

I floated the spheres and by changing their colors from blue to purple I created movement within the frame of the image, suggesting the medicine passing through the human body.

I later learned that the client had decided to generalize the product further and replaced the mask of the woman with a large white sphere. That's advertising.

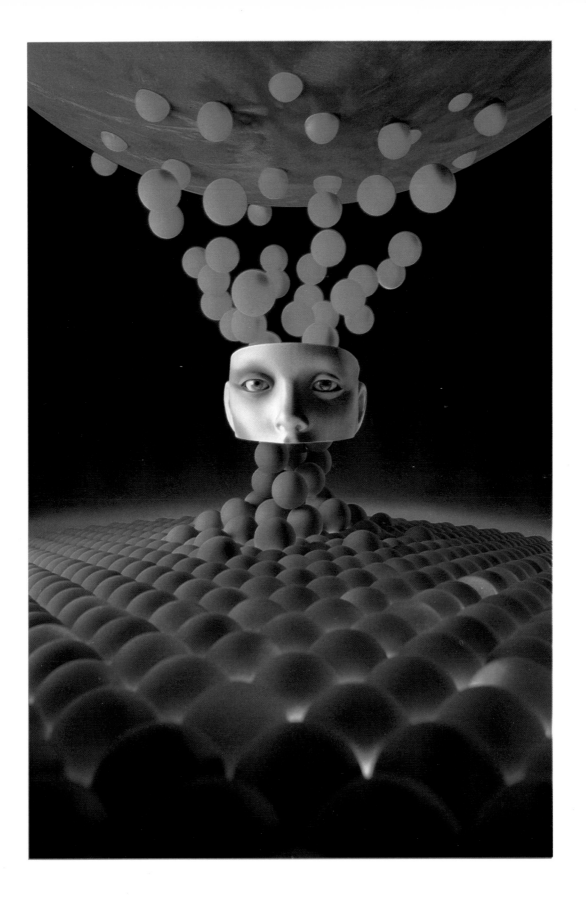

THE POWER WITHIN ❏ In the second ad for Dolisos, the client wanted me to create an image that symbolized the medicine's healing power.

The centerpiece is a pristine white sphere cracked open to expose the medication's complex core, which was created on a transparency lit from behind and highlighted by a starburst from a white laser reflecting in a tiny mirror. For the surface I used a lightbox with brightly colored gels to imply the progressive spirit of the company.

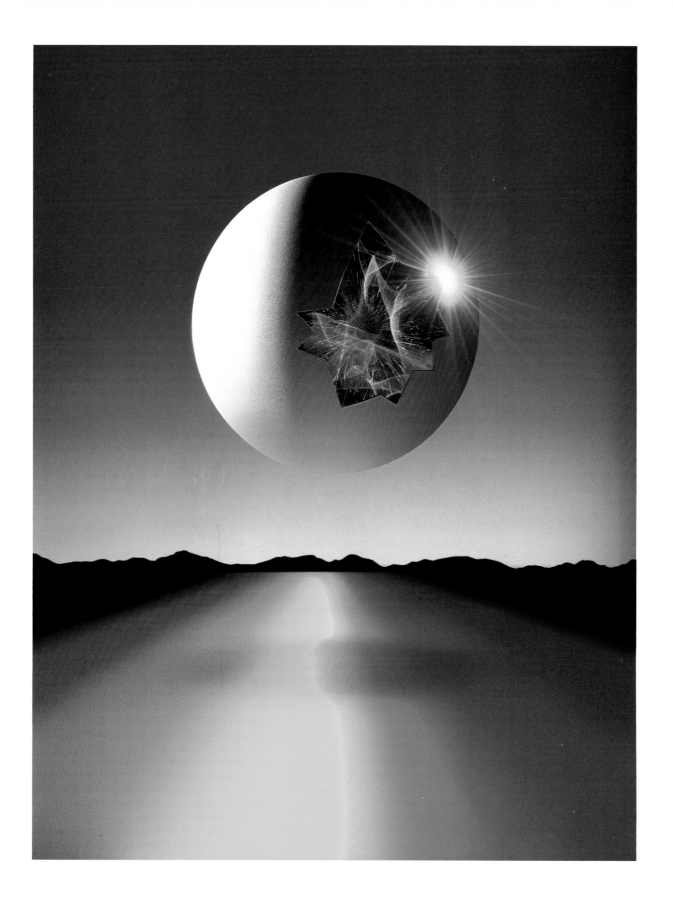

The theme of the sphere is a refrain in these four images for a Dolisos brochure. Each of them tells the story of a different phase of the company's strategy: "Visions for Tomorrow," "Markets to be Won," "New Fields of Communications," and "Distribution." All were created in the studio using ping-pong balls against enlarged images of skies and dimensional models custom built by a model maker.

The effect of movement was created by playing with the size of the balls and the addition of speed lines. The dimension was added by using wide-angle lenses, and in the lower right picture a tunnel was designed and constructed in perspective.

For the lower left image I used hexagons and built a model in the shape of the geographical outline of France, the company's home base.

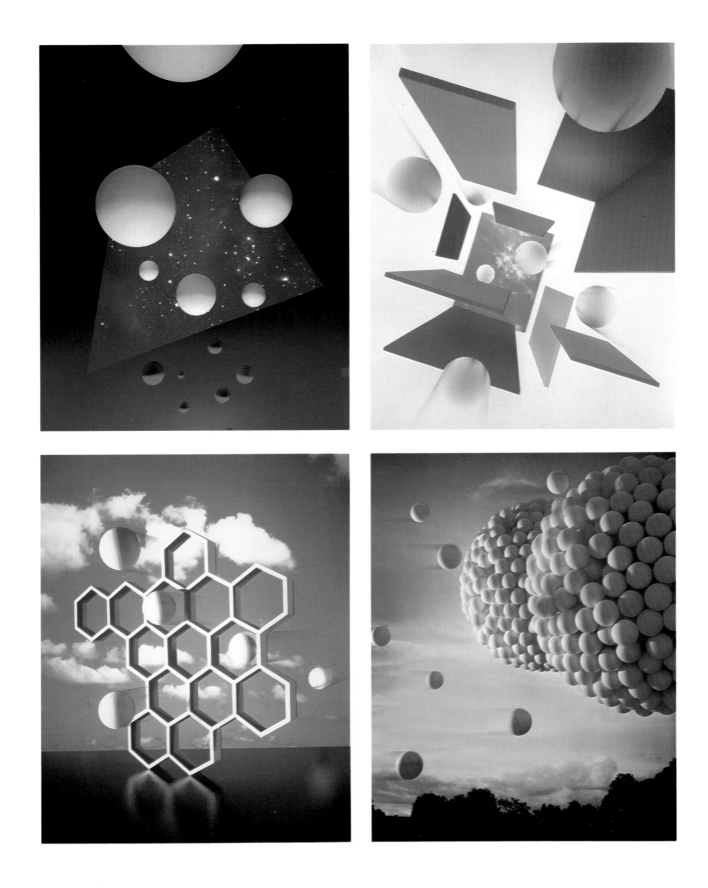

PROGRESSIVE AUTOMATION ❏ Simple logic is the foundation of good design. It was also, basically, the subject of this trade ad for General Electric.

The art director and I were working on a design that would illustrate a new program that progressively automates a corporation's entire operation.

I used a grid suggesting order, logic, and uniformity to represent the inherent corporate organization. By adding a dimension of depth to the grid, I created an environment that allowed each division to rise above the old organization while interconnecting in a new way. We used translucent colored beams of light through a direct-registered, double-exposure process to enhance the focal point of the story.

Frequently, I have been pigeonholed as a "special-effects" photographer. I do use effects but never for the sake of using them. The best effect of all is logic.

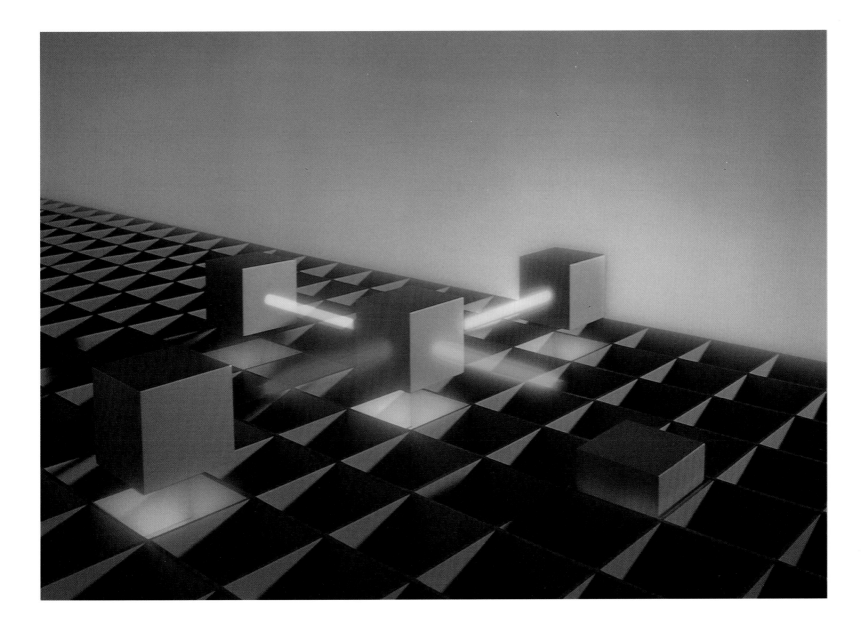

CHEMICAL REACTION ❏ As I listen to a client describe the parameters of a job, my mind flips through a mental file of elements, effects, and designs that might work for us. The more information I receive, the more quickly I can visualize a viable solution to the problem.

On the cover of a brochure, Chemical Bank wanted to tout their electronic transfer technology while creating with color and design an environment that would be user friendly. The "user" in this case would be the corporate comptroller to whom the brochure was targeted.

I bought three computer boards from an electronics supplier, added colored lights to make them look "sexy," then connected them to fiber-optic ribbons that in reality carry the transferred information. To attenuate the high tech and angular look of the circuit boards, I added bent thin strips of frosted Plexiglas that gently undulate out of the frame.

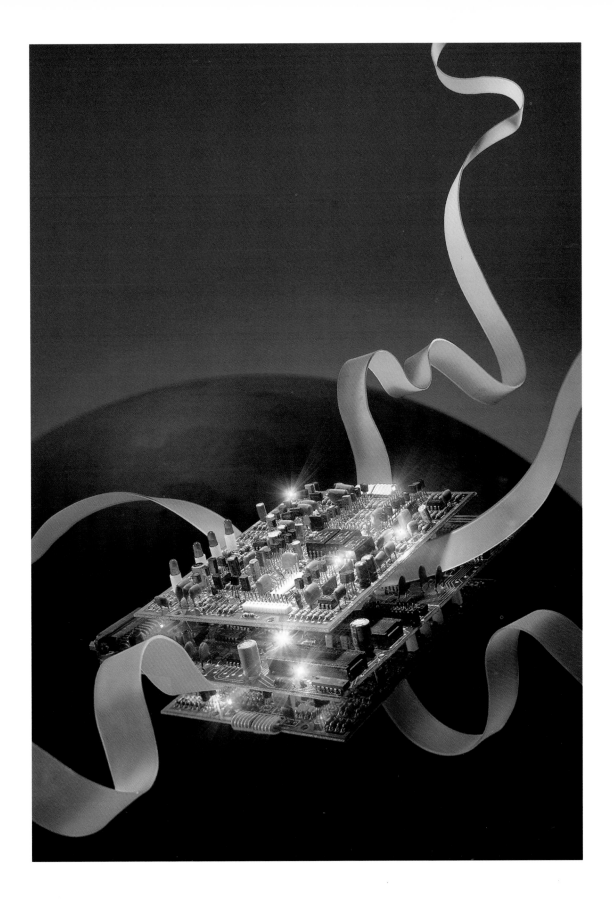

NETWORKING ❑ General Electric wanted the cover of their annual report to illustrate the dynamics of networking in their corporation.

I didn't want the image to have a single focal point. I used hot colors and a busy design to force the eye from left to right and top to bottom reinforcing the corporate-networking concept.

I studied the schematics to understand what "networking" meant in the context of this corporation and learned how the various work stations and terminals interacted with each other. To make this principle come alive, I created a three-dimensional model using two Plexiglas sheets.

I scored and drilled the surfaces, painted the rods, and added translucent pieces until the design of the image was as strong as the message.

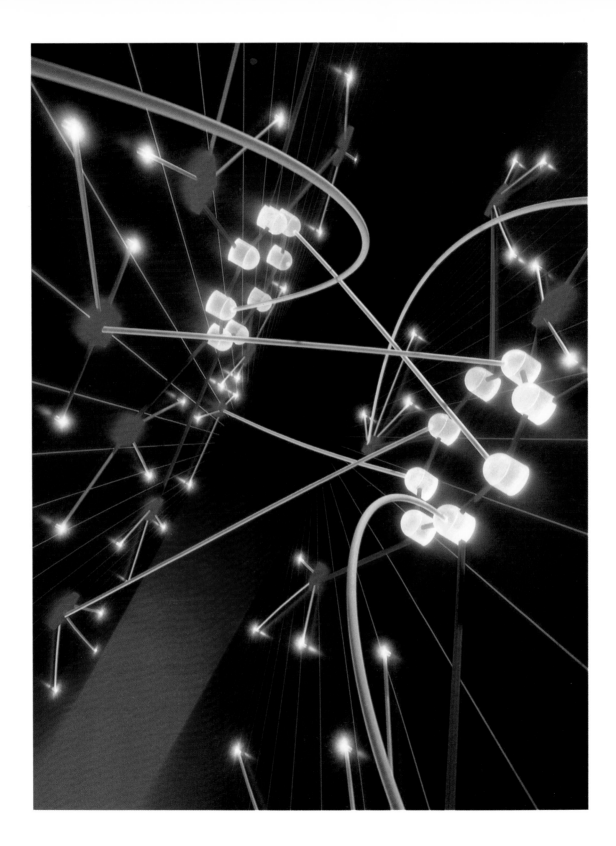

THE CREATIVE PROCESS ❏ I was asked to execute a terrific layout to advertise the wizardry behind the manufacturing of electronic switches. Technically, this was a difficult problem to solve. I had to build one large set to accommodate all the elements so they would visually fit together perfectly. Each bubble, because of its unique perspective to the camera, had to be individually cut around a custom-made, six-foot neon tube so the seam would disappear. The surface was a large sheet of translucent photographic material lit from underneath to simulate the diagram of the switches.

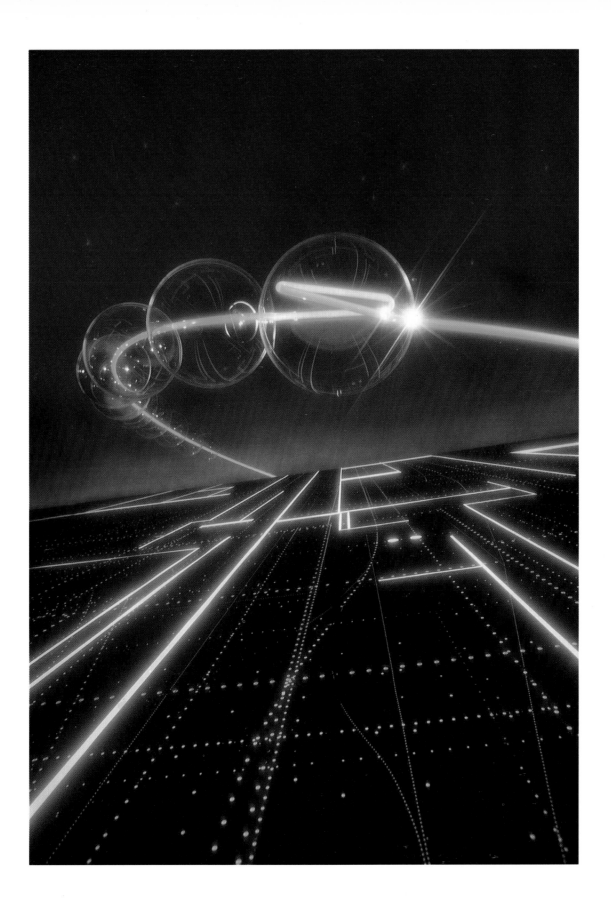

THE ELECTRIC BUG ❑ The props were still set up for an assignment that had produced some very serious work. It was time to unwind and have fun. I wasn't telling a story. I wasn't illustrating a concept. I was playing a visual game on my own time.

I experimented with a variety of shapes between the two hemispheres. I tried the sphere, and it felt right to me. Then, satisfied with the composition, I started to play with colors until it felt comfortable again. But there was still an element missing. I wanted to connect all the elements. That's when I remembered a striking image of lightning. The cycle was complete.

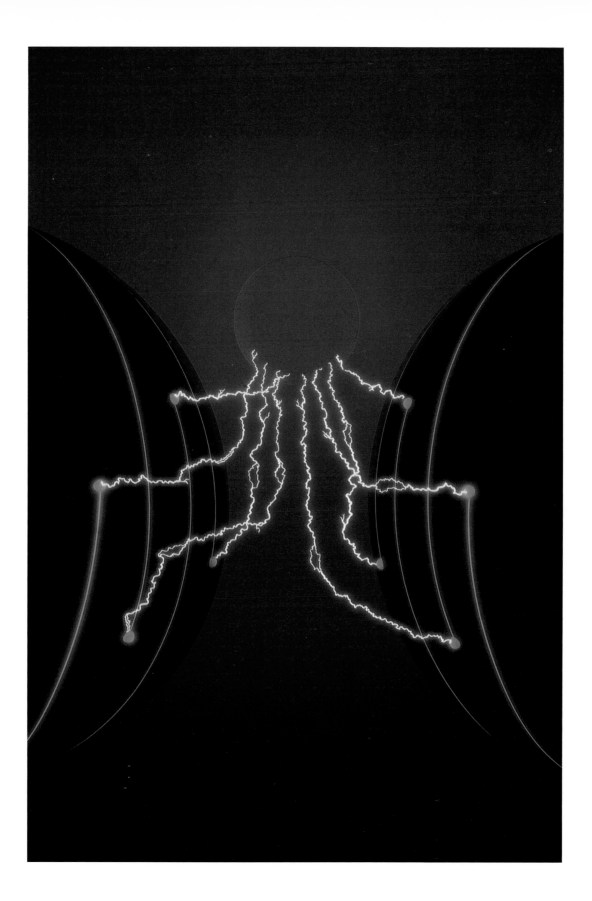

THE APPLE GRAPH ❏ This is an illustration of a graph. It's a simple principle, but a terrific concept. Each section of the symbolic apple is a division of the company. The white center is the corporate core.

This is a clever way of dramatically presenting what ordinarily would be rather boring corporate statistics. It was the client's idea.

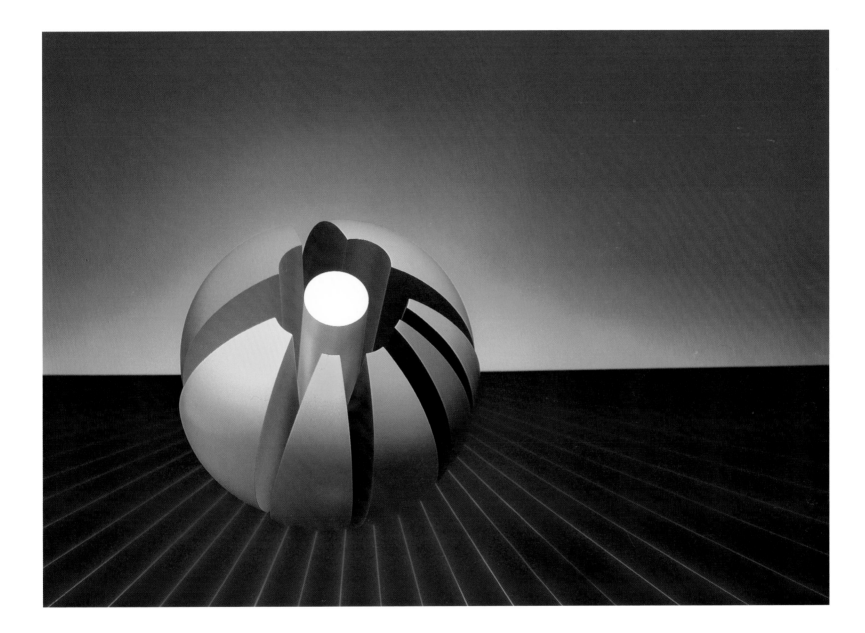

A-MAZ-ING ❑ This is one of my favorite images. It was not an assignment; it was pure indulgence and felt comfortable right from the start.

There are no special effects in this shot. But the image does have a special effect on me. I look at it and think of those times when I'm searching for an answer and wishing that I could find the light.

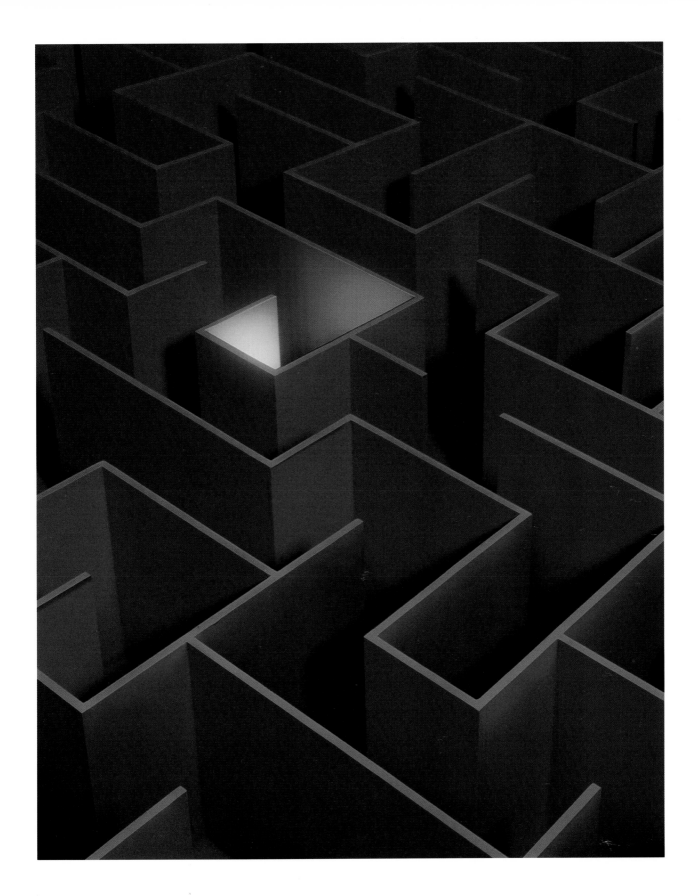

FLYING HIGH ❑ McDonald Douglas asked me to photograph a series of ads to reflect their company's vision. Since planes are not designed to have a six-month shelf life, the people who design them are light years ahead of the rest of us. Working with them gave me a feeling of living in a time beyond my own.

The art director and I chose the arrow as a design element to draw the eye toward the focal point of this image, thus conveying a message of future vision. The forced grid perspective combined with the gentle curve of the horizon underscores the high technology of the company. By using a large amount of black space around the focal point, we created a sense of vastness that transcended infinity and gave the client the latitude to also use this image as a wraparound cover for a brochure.

I base a lot of my work on personal experience. This image illustrates the awesome feeling I had the first time I stared out of the tiny window of the Concord, saw the faint impression of the earth's curvature against the thin afterglow of sunset, and was struck with the overwhelming wonder of man and flight.

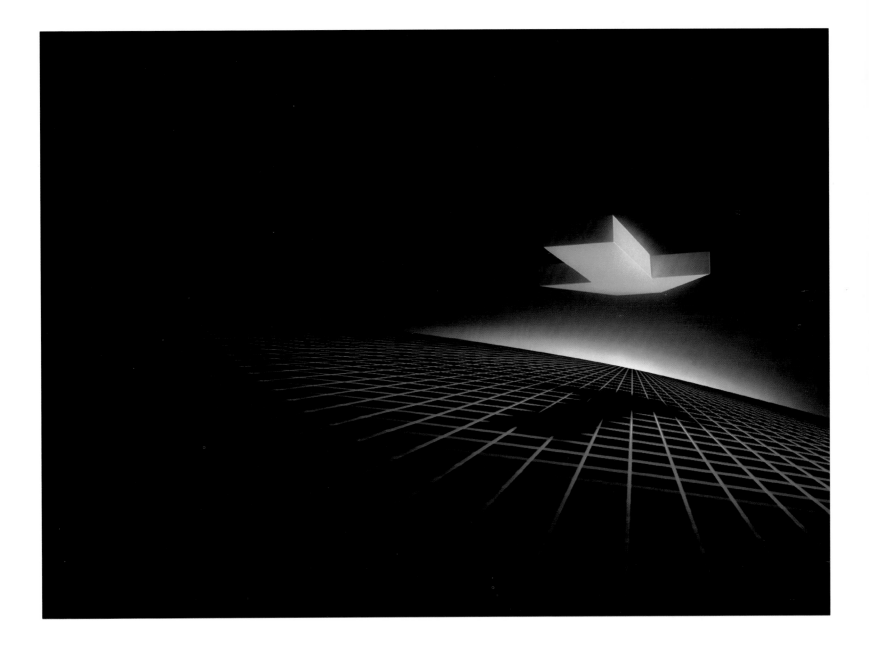

MINDFUL OF MAGRITTE ❑ Every year I take a few weeks "off" just to create generic images using elements, effects, and ideas that appeal to me and that may be applicable to future projects. This is one of those images.

I've always been a passionate fan of Magritte. After years of looking at his work, his surrealistic fantasies have unconsciously affected some of my thinking.

I designed, and then commissioned a model maker to build, the segmented sphere that floats over the surface. I had used the road as an element before, but for this shot I lit the center yellow line from underneath and placed it on top of a reflective surface to give it a more futuristic feeling. The small white balls serve the dual purpose of hiding the supporting rig under the large sphere and adding interest to the composition.

The additional rewards of my "time off" were that eventually this image was selected for a cover of *Science Digest*.

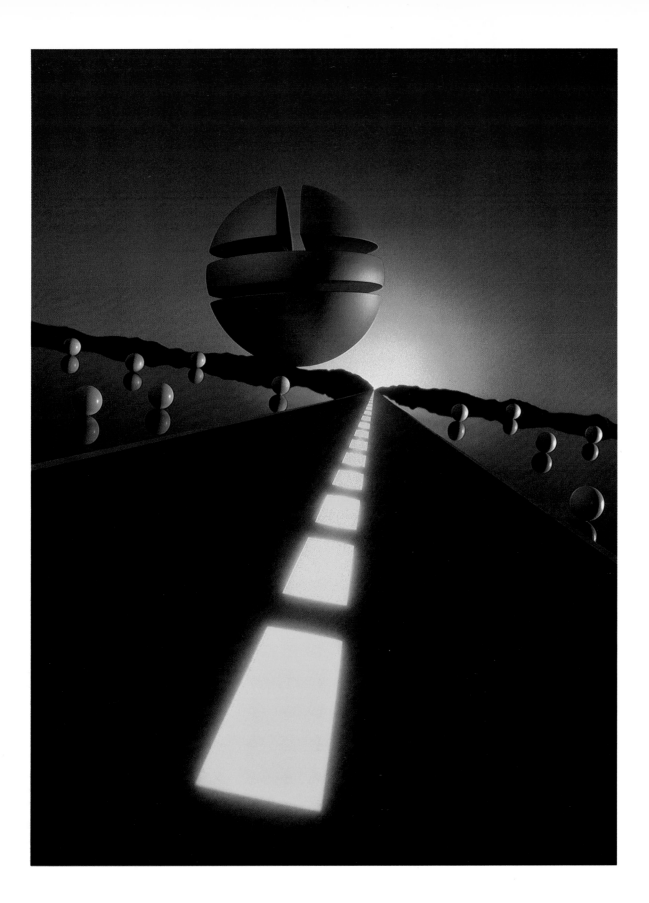

An Unexpected Vacation ❑ I received a call at the

studio asking me to estimate a layout that was described roughly as a robot's arm holding the client's product. Clearly, it was a tight budget with a tight deadline, so building an arm from scratch at a cost of thousands of dollars was out of the question. I had to find a fast and less expensive solution.

I already had part of the problem solved. I knew where to find the robot. It was a toy. But with modifications, my model maker could make it come alive. By the time I could get back to my prospective client, the job had suffered instant death.

But I didn't want the idea to die completely, so I created a shot for myself.

The potential of robot power and the effect of that power on our economy is an issue that generates tremendous interest. I created several variations on this theme that could apply to many industries, but this is my favorite.

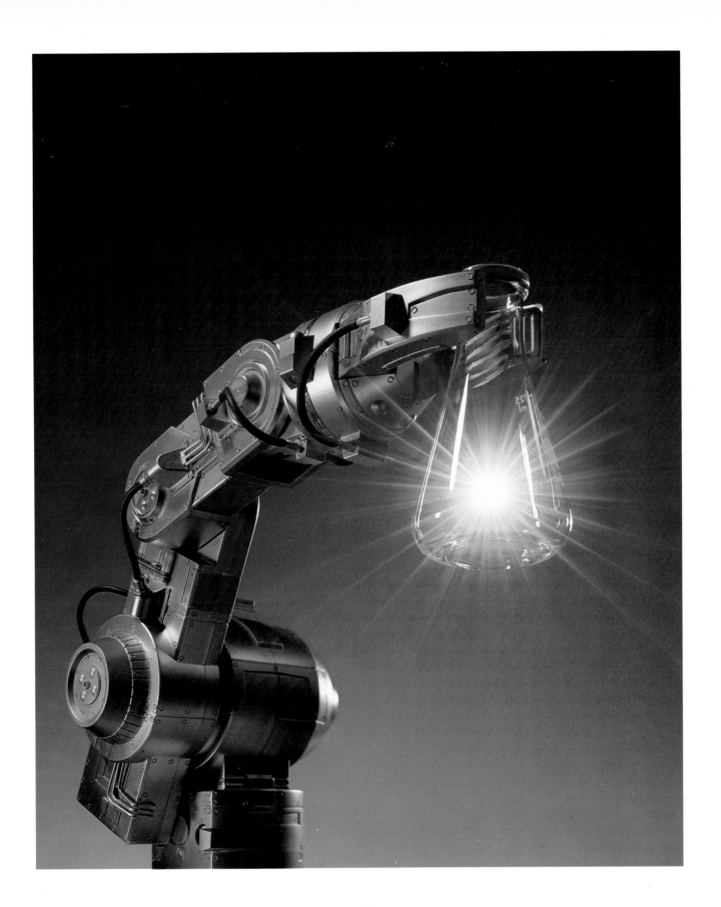

GEORGIA ON MY MIND ❑ In my wanderings around Manhattan, I found a store on Columbus Avenue that sells, among butterflies, beetles, and various insects, the most exquisite animal skeletons, available in whole or in part, depending upon your preference.

That day my preference was a steer's skull, displayed in the middle of the window, looking at me. I immediately thought, Georgia O'Keeffe! and decided to do an abstract portrait.

After the visual direction was decided, the rest was a process of free thinking.

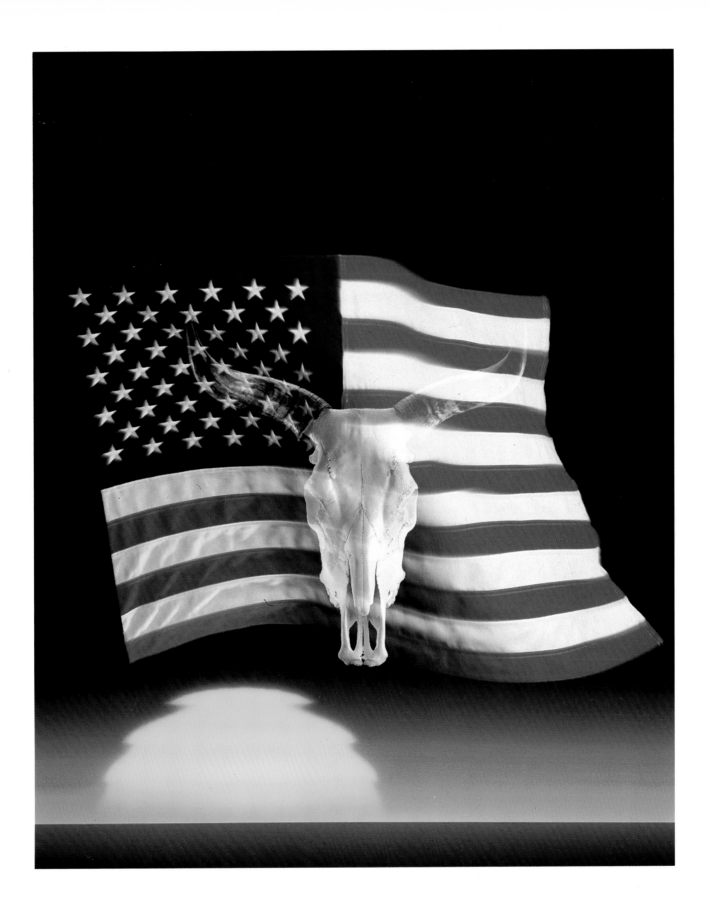

THINKING HEAD ❑ Fifteen years ago I produced a piece of sculpture, consisting of a black Plexiglas box encasing two white plaster heads connected by a neon tube, that still hangs in the entrance to my studio. The art director, who was working on Bell Labs' annual report, noticed the sculpture when he arrived and immediately thought that it graphically told his company's story.

Bell Labs is one of the largest and most sophisticated research laboratories in the world, with a reputation for excellence that emanates from their renowned brain trust. The "thinking heads" connected by the glowing, red beam of light perfectly illustrate "communication." Their environment, a scientific, high-tech tunnel, was difficult to create The next time you're in an old, rickety elevator, wondering if you're going to make it to your floor, look up. The chances are you'll see a cheap, plastic grill covering the lights. That's the grill I used—with a little improvement.

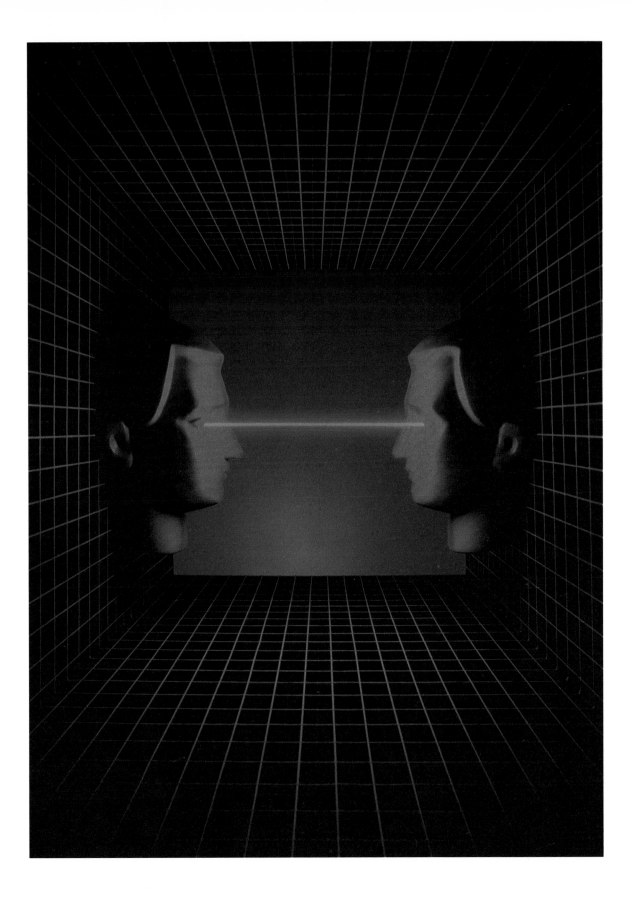

The problems inherent in advertising the capabilities of corporations are often similar, but they are never identical. Each corporation has a unique philosophy that dictates the design and elements of the final image.

It's impossible to create an image without information. I need verbal cues from the client to trigger a visual. The clearer these cues, the better our communication, the more effective the ultimate image will be.

Bell Atlantic knew exactly what they wanted to say, they just didn't know how to visualize it. The explanation of the problem was so clear, the art director's language so precise, that conceiving the drawings for these five images took less than a week.

I had just finished a series of very "straight," "down to earth" jobs, and I really needed to let my imagination loose. From the first phone call, to the first sketches, to the final images, this was a fabulous assignment that generated tremendous conceptual energy.

THE SEED ❑ The symbolism here is straightforward—if you use Bell Atlantic's "genius," your company will grow strong.

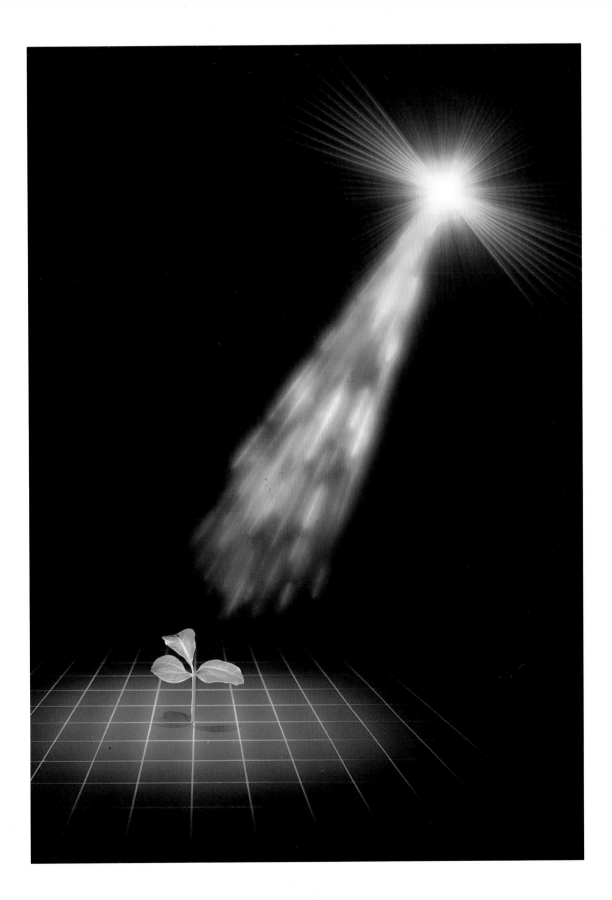

THE FREEDOM TO FLY ❏ This image continues the "genius" theme of Bell Atlantic's successful television campaign. This photograph focuses on the successful work Bell did to help revitalize an airline's communications network.

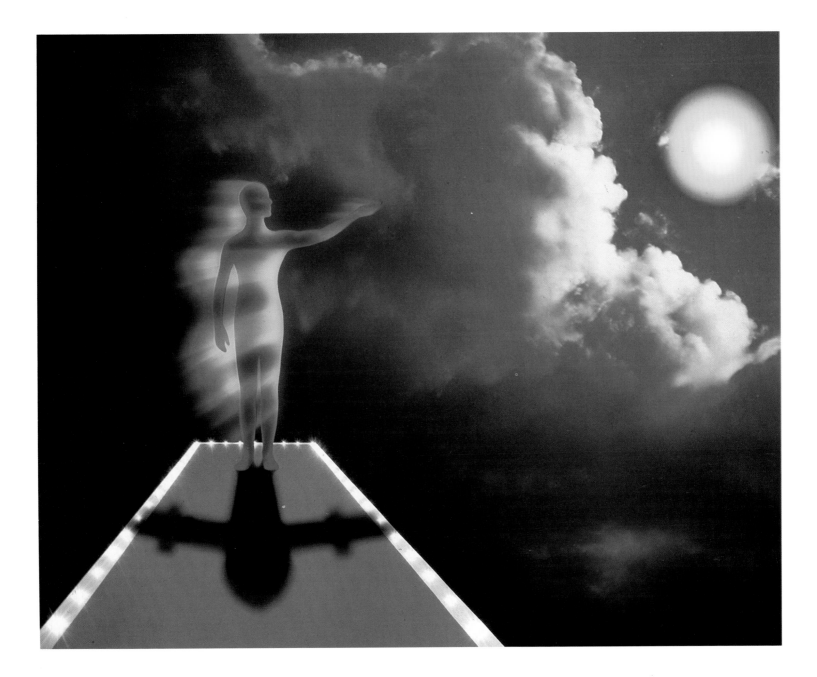

SPACE-SHARING INFORMATION ❑ "How can two divisions of a company profit from one another's knowledge?" The answer is Bell Atlantic's "genius." That "genius," or capability, is symbolized by a core of light through which all information flows.

I chose two slightly differently designed mazes to represent each division's uniqueness. I built two models that were two feet by four feet and painted them in complementary colors to imply corporate parentage. I suspended one above the other and visually connected them with a gentle stardust effect to illustrate the smooth exchange of knowledge between the two opposing surfaces.

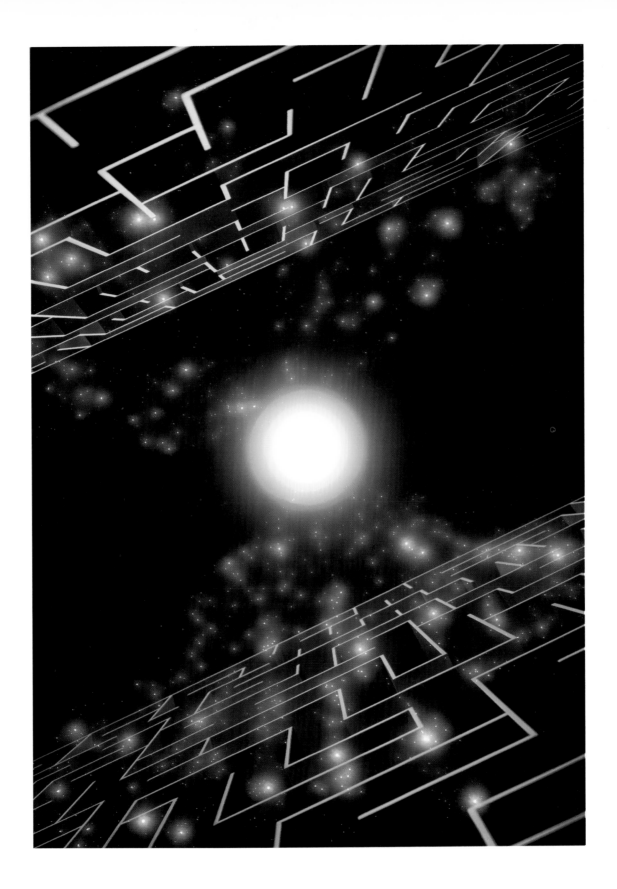

TECHNOLOGY IN HAND ❑ The photographer's challenge in making images for advertising is to create sufficient emotion to grab the audience and visually stop them on the page. When the subject of the photograph is not sufficiently emotional, the photographer must create the feeling with color and design.

This image illustrates the potential of the combined power of man and technology. To create the first effect I subtly blended a line drawing with a photograph of a live model's hand. The beam of light is a neon tube, creating the illusion of the force of that technology.

The cool coloring of the image suggests the invisible power of a telecommunications company that carries sound silently through a network of billions of cables and lines.

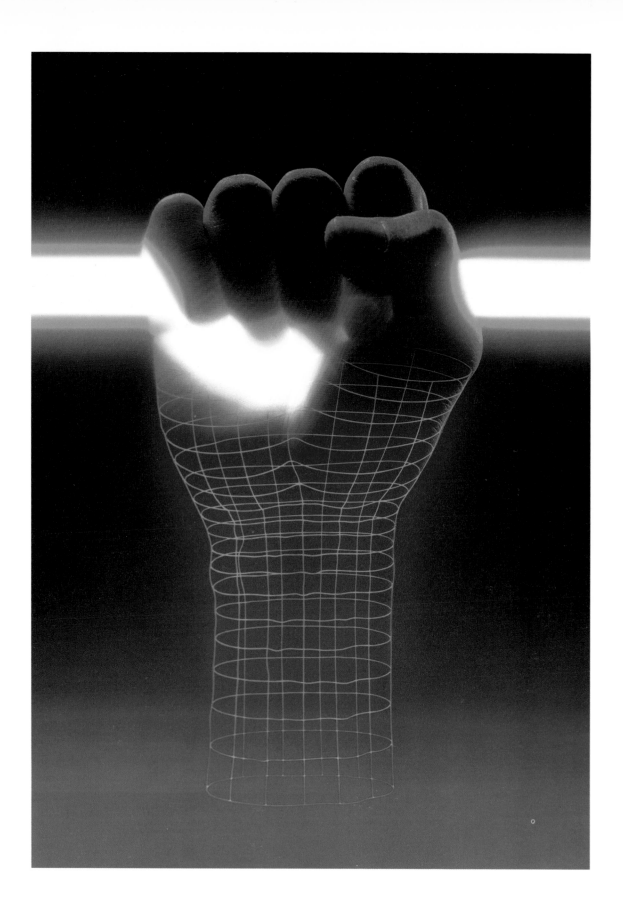

THE ACT OF GIVING ❑ The problem here was to illustrate the transference of information through Bell Atlantic's telecommunications networking capabilities.

The hand at the top of the image has a human shape with a blue aura that represents Bell Atlantic. The beams of soft light extending upward from the fingertips out of the frame create an illusion of power that contrasts well with the gentle position of the hand providing services. The receiving human hand at the bottom of the frame represents the client who will benefit from those services. The core of hot light is the force of Bell's power and is again used as a symbol for the capabilities potential of the company.

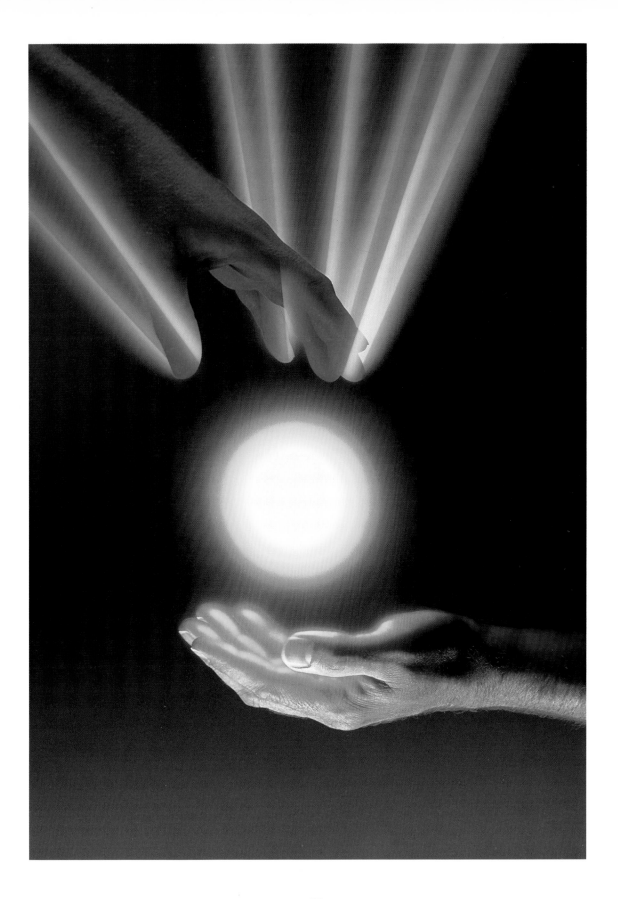

The illustrations on these pages show some of my images in the context in which they were used. In some cases, where a series of photographs were taken, I have picked a different one to discuss than the client chose.

Page 6

Client: *Omni* Magazine
Art Director: Richard Bleiweiss
Agency: In house
Camera: Nikon F2
Lenses: Nikkor 28mm, 55mm, 105mm
Film: Kodachrome 25

Page 8

Client: Virginia Beach,
 Department of Economic Development
Art Director: Charles Ober
Agency: Arthur Polizos Associates, Inc.
Camera: Sinar P 4×5
Lenses: Schneider 121mm, 210mm
Film: Ektachrome 100

Page 11

Client: *AT&T* Magazine
Art Director: Tim Ryan
Agency: In house
Camera: Nikon F2
Lens: Schneider 35mm
Film: Kodachrome 25
Also stock to *Omni* magazine

Page 13

Client: General Motors
Art Director: Bruce Engelson
Agency: N.W. Ayer/Detroit
Camera: Sinar P 4×5
Lens: Schneider 121mm
Film: Ektachrome 64

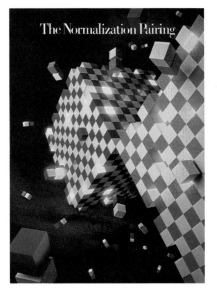

Page 15

Client: General Motors
Art Director: Bruce Engelson
Agency: N.W. Ayer/Detroit
Camera: Sinar P 4×5
Lens: Schneider 121mm
Film: Ektachrome 64

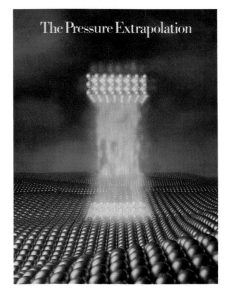

Page 17

Client: General Motors
Art Director: Bruce Engelson
Agency: N.W. Ayer/Detroit
Camera: Sinar P 4×5
Lenses: Schneider 121mm, 210mm
Film: Ektachrome 64
 Triple exposure

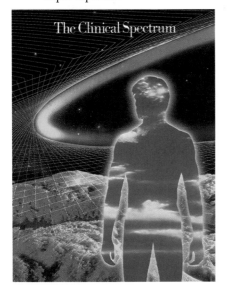

Page 19

Client: General Motors
Art Director: Bruce Engelson/Detroit
Agency: N.W. Ayer/Detroit
Cameras: Nikon F2, Sinar P 4×5
Lenses: Nikkor 25−50mm, Schneider 210mm
Films: Kodachrome 25, Ektachrome 100

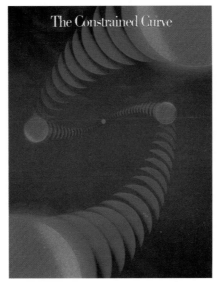

Page 23

Client: Eastman Kodak
Art Director: Ted Plair
Agency: J. Walter Thompson/New York
Camera: Nikon F2
Lens: Nikkor 28mm
Film: Kodachrome 25

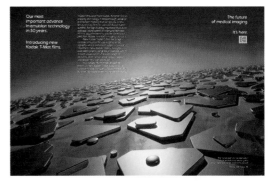

Page 27

Client: The Coca-Cola Company
Art Directors: Len Fury and Alicia Landon
Agency: Corporate Annual Report
Camera: Nikon F2
Lens: Nikkor 20mm
Film: Kodachrome 25

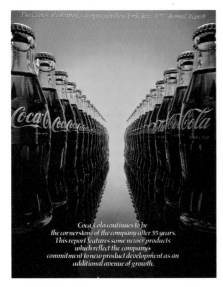

Page 33

Client: The National Geographic Society
Art Director: Dave Seager
Agency: In house
Camera: Sinar P 4×5
Lens: Schneider 210mm
Film: Ektachrome 64
 Electronic pixelization

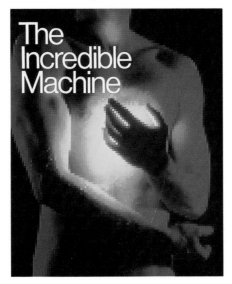

Page 34

Client: National Geographic Society
Art Director: Dave Seager
Agency: In house
Camera: Sinar P 4×5
Lenses: Schneider 210mm
Film: Ektachrome 100

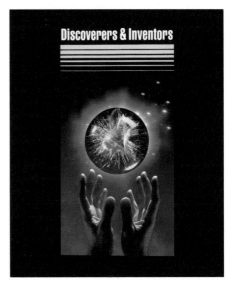

Page 41

Client: Hammermill Paper
Art Director: Tammy Sweet
Agency: BBDO
Camera: Sinar P 4×5
Lens: Schneider 121mm
Film: Ektachrome 64

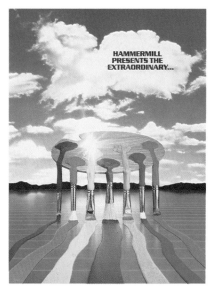

Page 43

Client: IBM
Art Director: Bill Cadge
Agency: In house
Camera: Sinar P 4×5
Lens: Schneider 210mm
Film: Ektachrome 64

Page 49

Client: Duggal Color Project
Art Director: Dolores Hansen
Agency: In house
Cameras: Sinar P 4×5, Nikon F2
Lenses: Nikkor 105mm, Schneider 210mm
Films: Kodachrome 25, Ektachrome 64

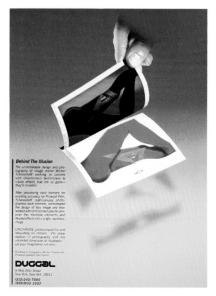

Page 51

Client: Panasonic
Art Director: Frank Santelia
Agency: In house
Camera: Sinar P 4×5
Lenses: Schneider 90mm, 121mm, 210mm
Film: Ektachrome 100

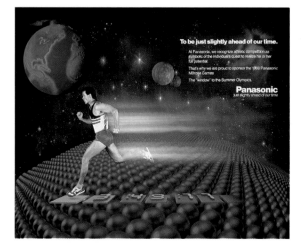

Page 53

Client: Allegheny General Hospital
Art Director: Joe Cancilla
Agency: Burson-Marsteller/Pittsburgh
Camera: Sinar P 4×5
Lenses: Schneider 90mm, 210mm
Film: Ektachrome 64
 Quadruple exposure

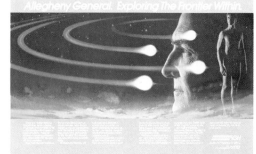

Page 55

Client: *Science Digest*
Art Director: Russell Zolan
Camera: Nikon F2
Lens: Nikkor 35mm
Film: Kodachrome 25

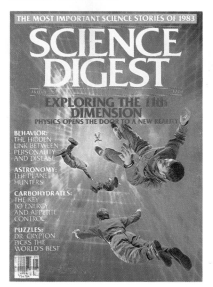

Page 61

Client: Hydrocurve
Art Director: Barbara White
Agency: Grey Medical
Camera: Sinar P 4×5
Lens: Schneider 210mm
Film: Ektachrome 64
 Quadruple exposure

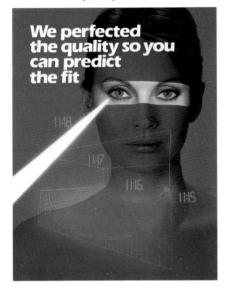

Page 63

Client: Monarch Resources
Art Director: Mel Ciociola
Agency: Ciociola & Co.
Camera: Sinar P 4×5
Lens: Schneider 210mm
Film: Ektachrome 64

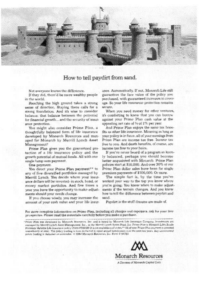

Page 65

Client: Monarch Resources
Art Director: Stan Kovics
Agency: Ciociola & Co.
Camera: Sinar P 4×5
Lenses: Schneider 210mm
Film: Ektachrome 64

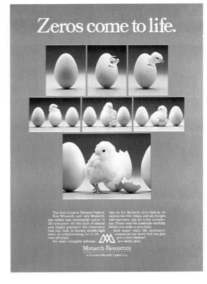

Page 69

Client: *American Baby* Magazine
Art Director: Jean Dzienciol
Camera: Nikon F2
Lens: Nikkor 35mm
Film: Kodachrome 25

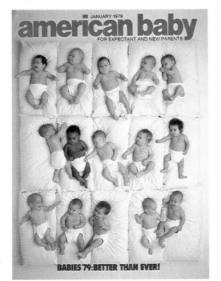

Page 71

Client: *American Baby* Magazine
Art Director: Michel Tcherevkoff
Stock photograph
Camera: Nikon F2
Lens: Nikkor 105mm
Film: Kodachrome 64

Page 73

Client: AT&T
Art Director: Steve Apostolou
Agency: Deutsch, Shea, Evans
Camera: Sinar P 4×5
Lens: Schneider 90mm
Film: Ektachrome 64

Page 75

Client: Prescriptives
Art Director: Jim Gager
Agency: In house
Camera: Sinar P 4×5
Lens: Schneider 210mm
Film: Ektachrome 64

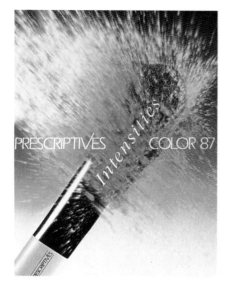

Page 79

Client: Frank B. Hall Insurance Company
Art Director: James Talarico
Agency: Contempra Communications
Camera: Sinar P 4×5
Lens: Schneider 121mm
Film: Ektachrome 64

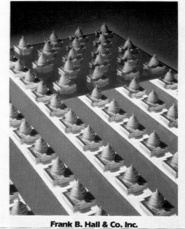

Page 80

Client: Frank B. Hall Insurance Company
Art Director: James Talarico
Agency: Contempra Communications
Camera: Nikon F2
Lens: Nikkor 28mm
Film: Kodachrome 25

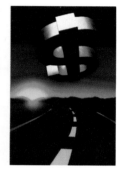

Page 83

Client: Frank B. Hall Insurance Company
Art Director: James Talarico
Agency: Contempra Communications
Camera: Nikon F2
Lens: Nikkor 28mm
Film: Kodachrome 25

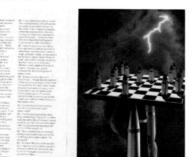

Page 85

Client: Frank B. Hall
Art Director: James Talarico
Agency: Contempra Communications
Camera: Nikon F2
Lenses: Nikkor 24mm
Film: Kodachrome 25

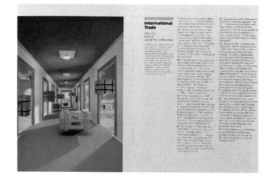

Page 87

Client: Frank B. Hall Insurance Company
Art Director: James Talarico
Agency: Contempra Communications
Camera: Nikon F2
Lens: Nikkor 28mm
Film: Kodachrome 25

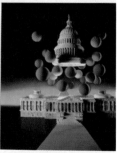

Page 89

Client: Frank B. Hall Insurance Company
Art Director: James Talarico
Agency: Contempra Communications
Camera: Nikon F2
Lens: Nikkor 28mm
Film: Kodachrome 25

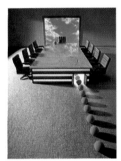

Page 95

Client: Richard D. Irwin
Art Director: Paula Meyers
Stock photograph
Camera: Sinar P 4×5
Lens: Schneider 210mm
Film: Ektachrome 100

Page 97

Client: Dolisos Pharmaceutical
Art Directors: Michel Tcherevkoff
 Charles Barral
Agency: France Conseil/Paris
Camera: Nikon F2
Lens: Nikkor 35mm
Film: Kodachrome 25

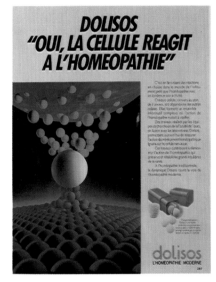

Page 101

Client: Dolisos Pharmaceutical
Art Director: Charles Barral
Agency: France Conseil/Paris
Camera: Sinar P 4×5
Lens: Schneider 121mm
Film: Ektachrome 64

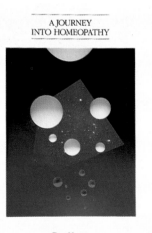

Page 103

Client: General Electric
Art Director: Jack Jones
Agency: In house
Camera: Nikon F2
Lens: Nikkor 55mm Micro
Film: Kodachrome 25

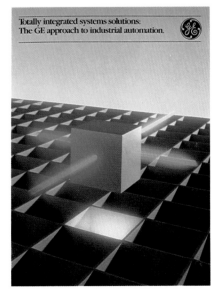

Page 105

Client: Chemical Bank
Art Director: Tom Papas
Agency: In house
Camera: Sinar P 4×5
Lens: Schneider 121mm
 Double exposure

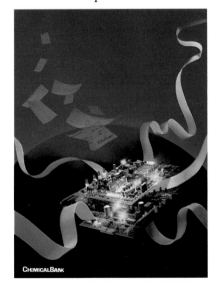

Page 107

Client: GTE
Art Director: Myles Dacre
Agency: Corpcon
Camera: Nikon F2
Lens: Nikkor 24mm
Film: Kodachrome 25

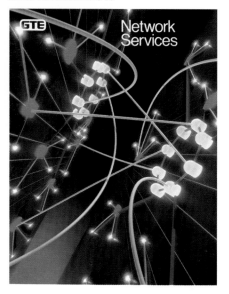

Page 109

Client: T. Bar
Art Director: Robin McGrath
Agency: R.C. Communications
Camera: Nikon F2
Lens: Nikkor 24mm
Film: Kodachrome 25

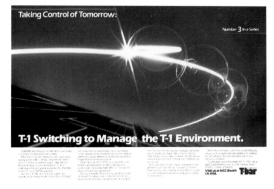

Page 113

Client: AT&T
Art Director: Dick Hess
Agency: In house
Camera: Sinar P 4×5
Lens: Schneider 210mm
Film: Ektachrome 64

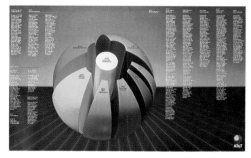

Page 119

Art Director: Michel Tcherevkoff
Stock photograph
Camera: Nikon F2
Lens: Nikkor 24mm
Film: Kodachrome 25

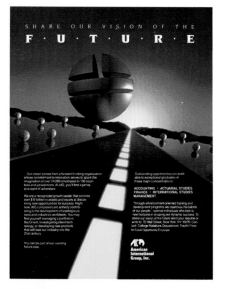

Page 125

Client: Bell Laboratories
Art Director: Vito Abraitis
Agency: In house
Camera: Nikon F2
Lens: Nikkor 24mm
Film: Kodachrome 25

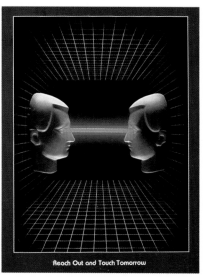

Page 144

Client: Manufacturers Hanover Corporation
Art Director: Combined effort
Agency: Murtha, DeSola, Finsilver, Fiore, Inc.
Camera: Sinar P 4×5
Lenses: Schneider 90mm, 210mm
Film: Ektachrome 100

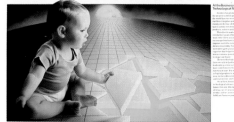

INDEX

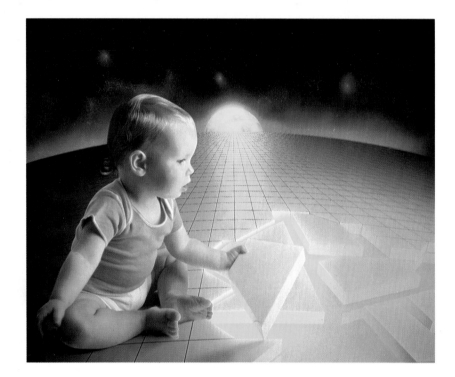